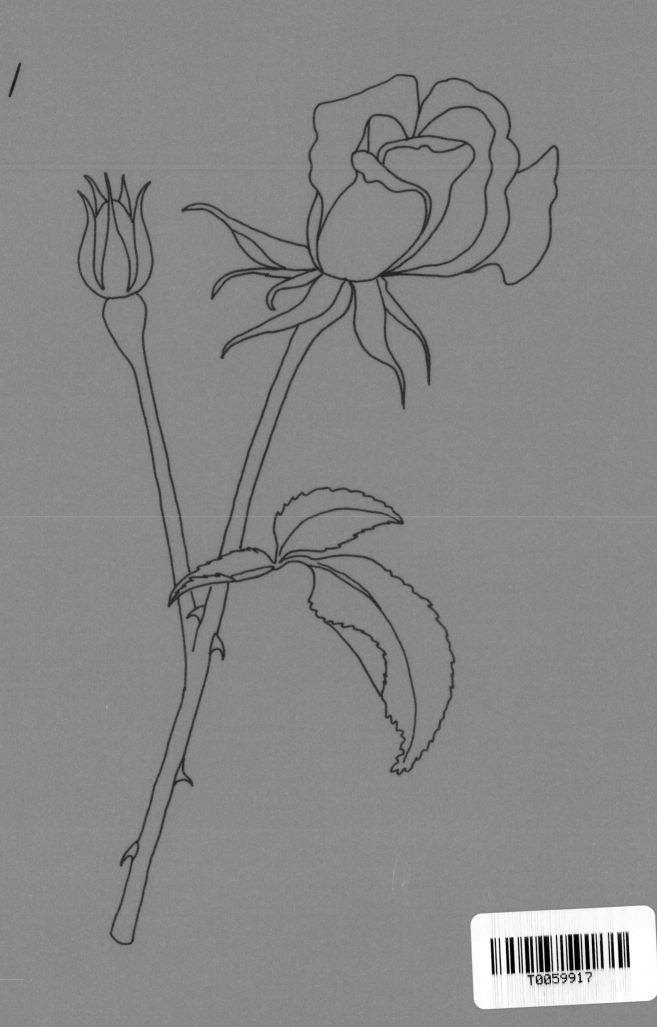

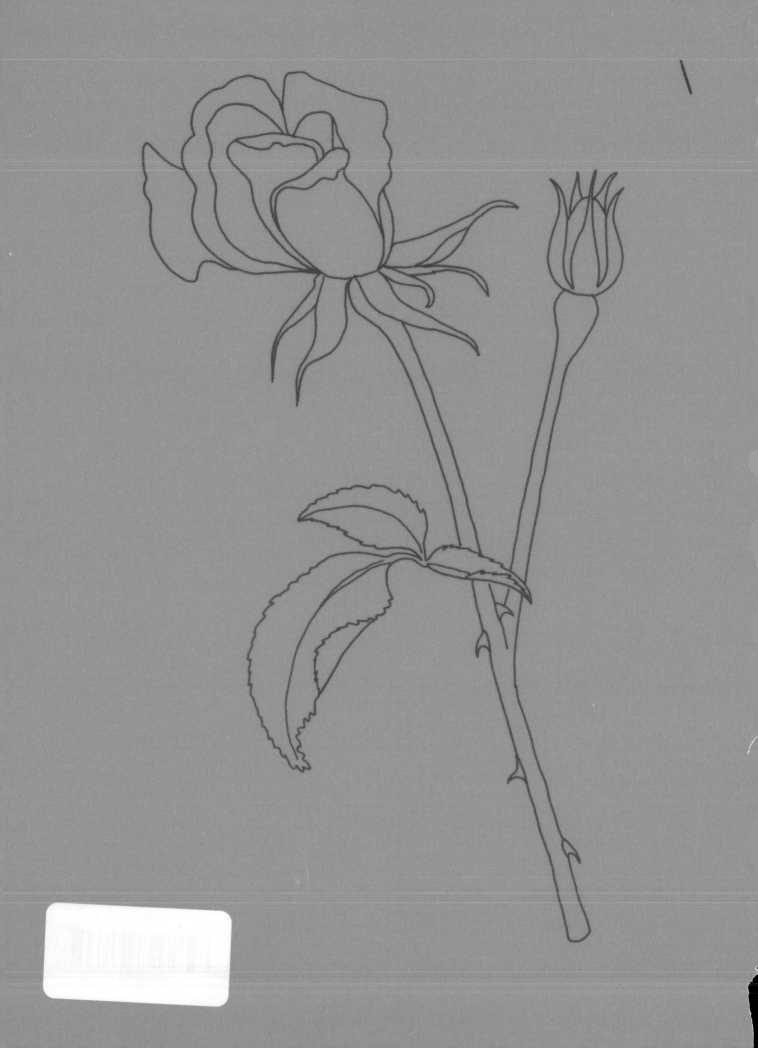

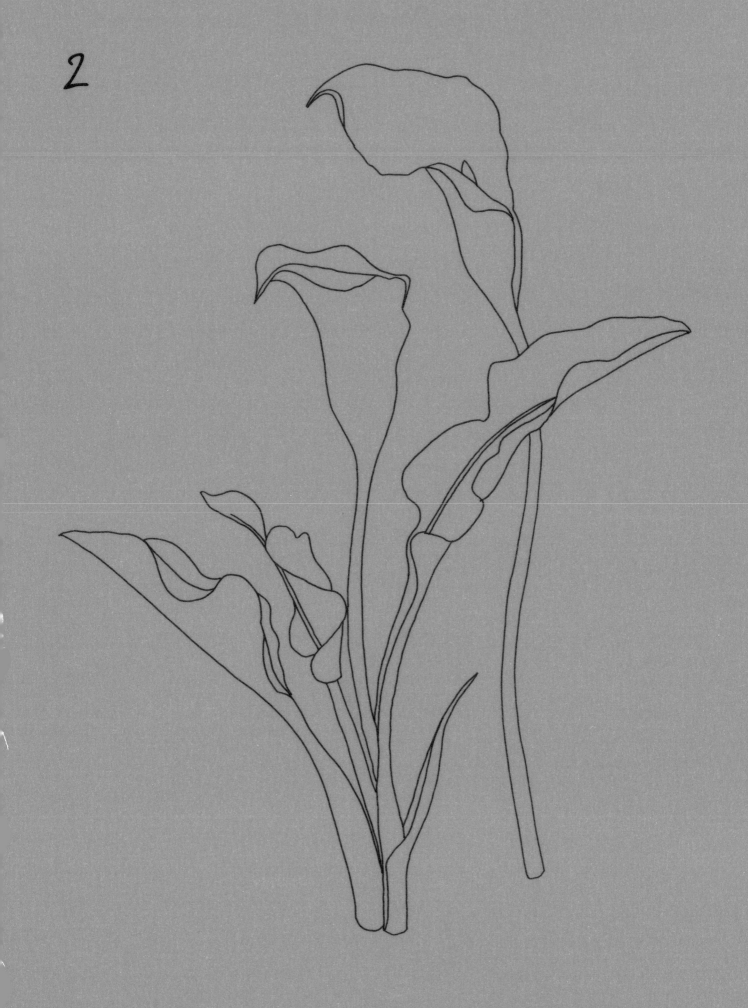

2

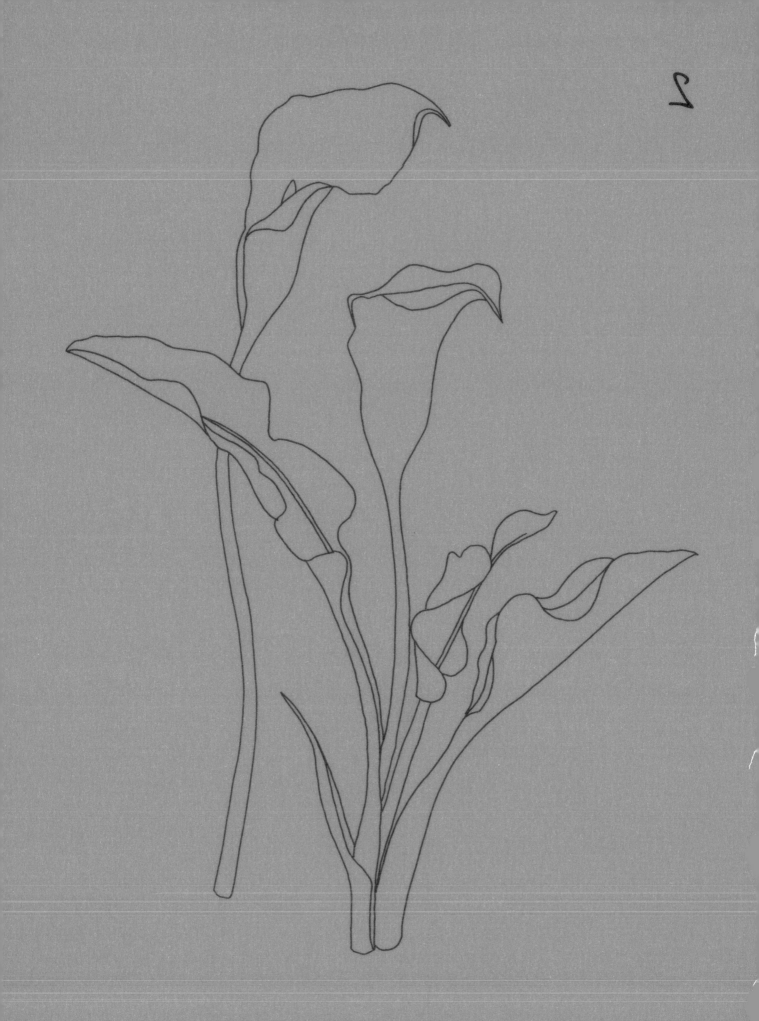

3

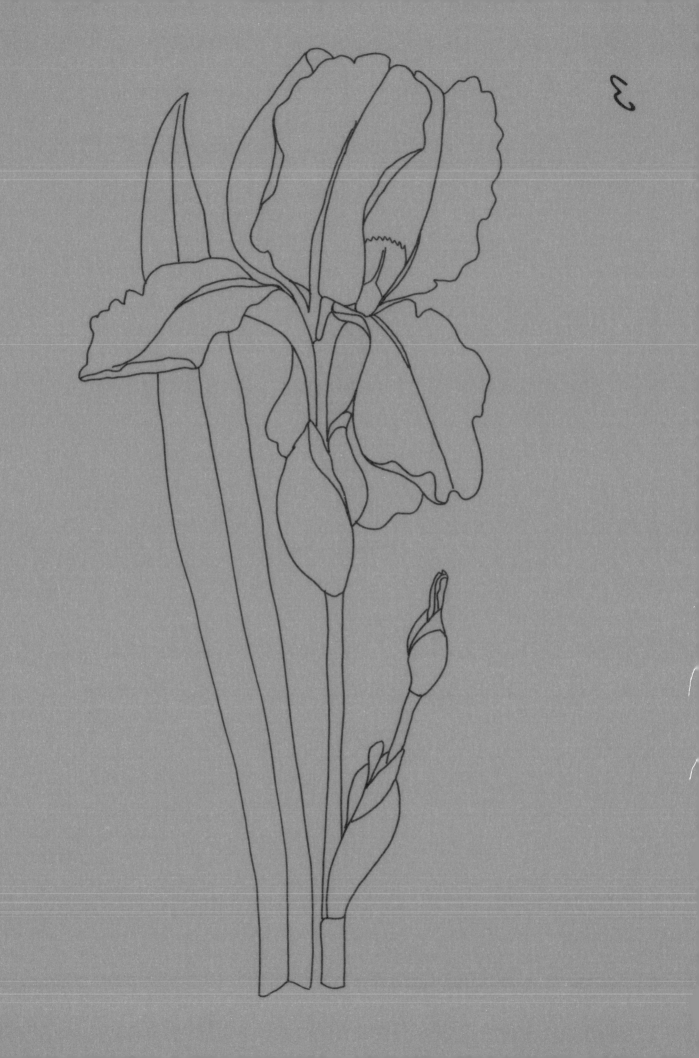

3

4

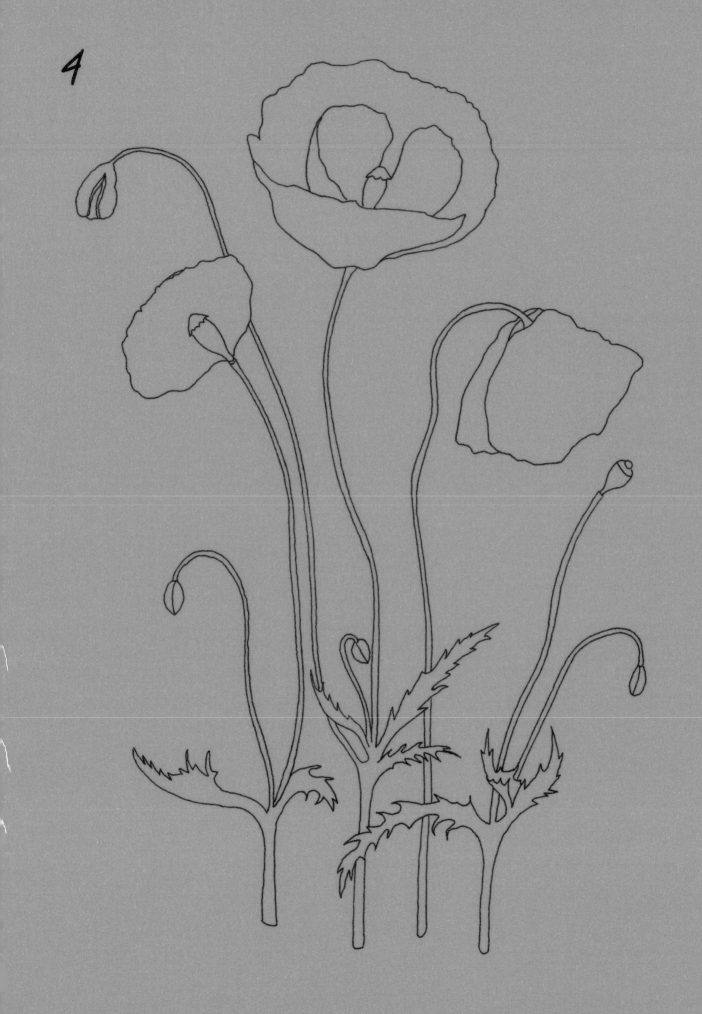

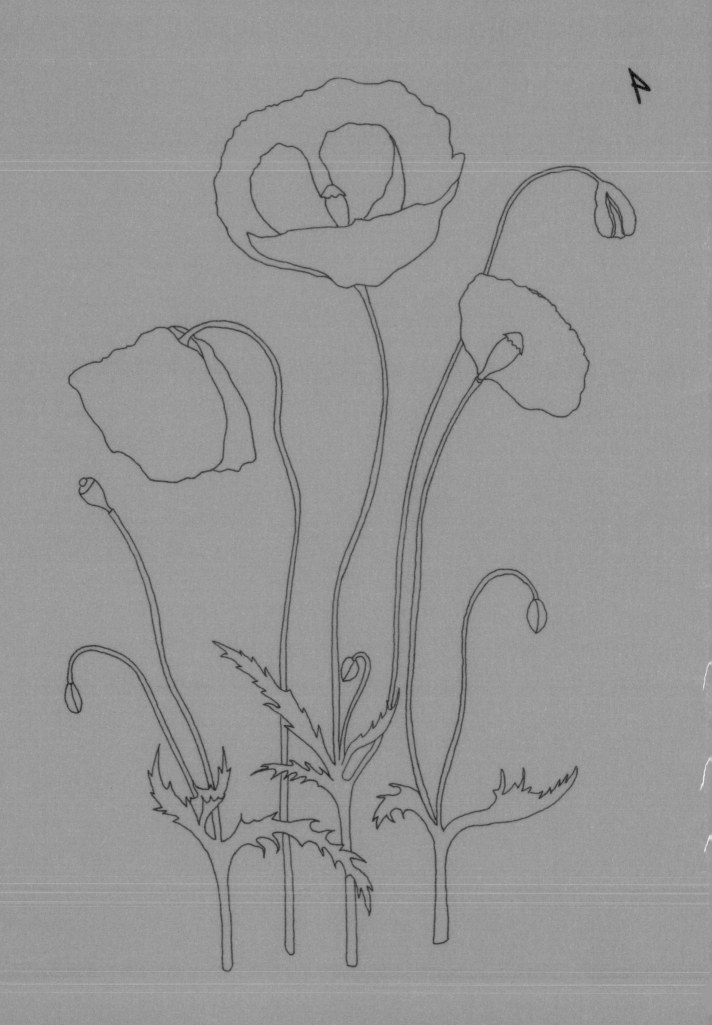

5

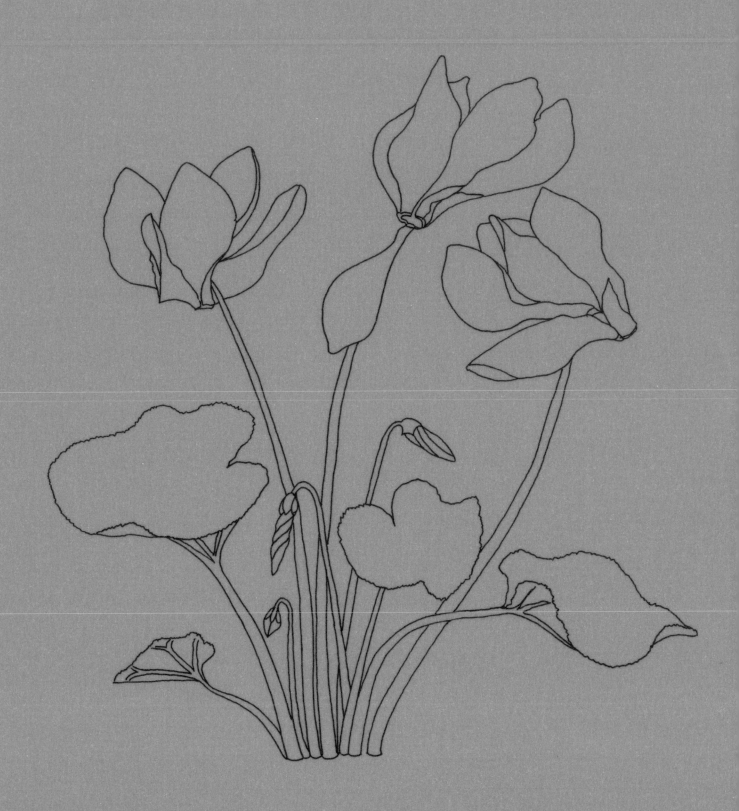

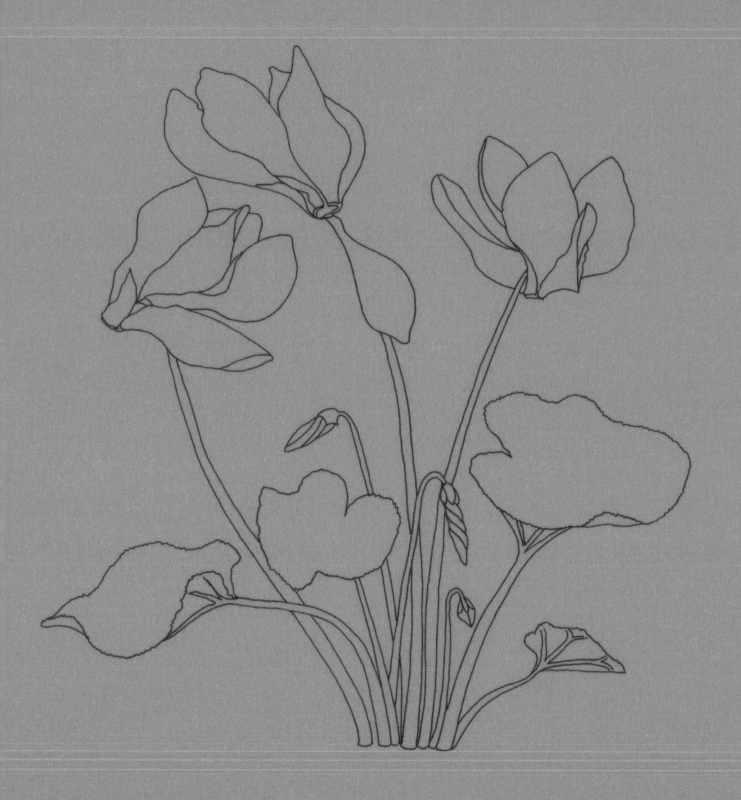

6

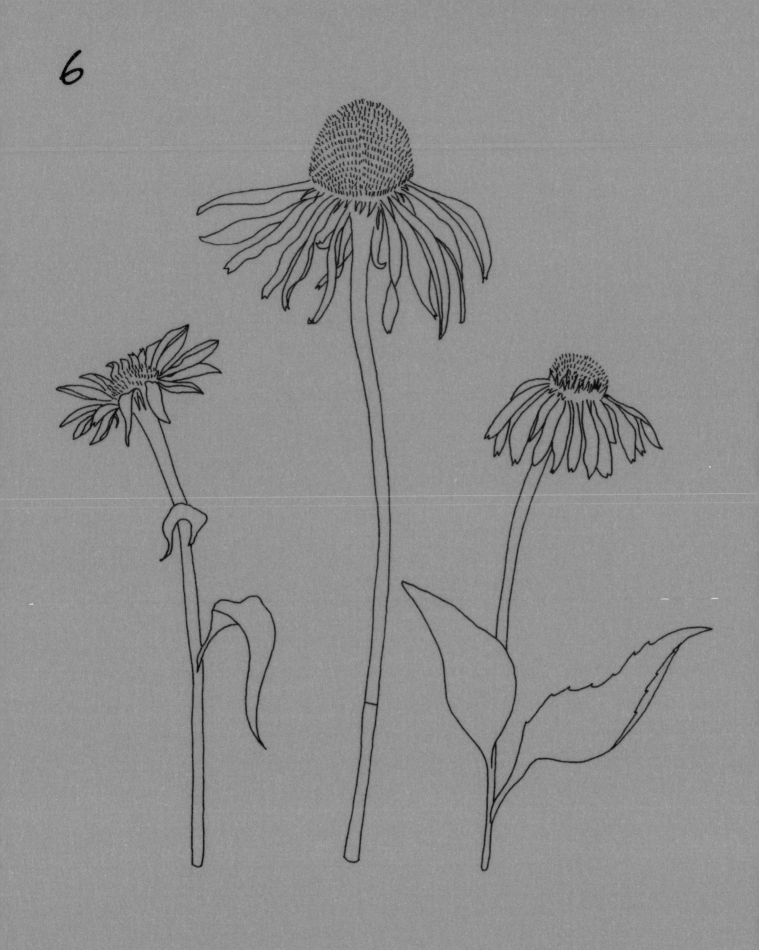

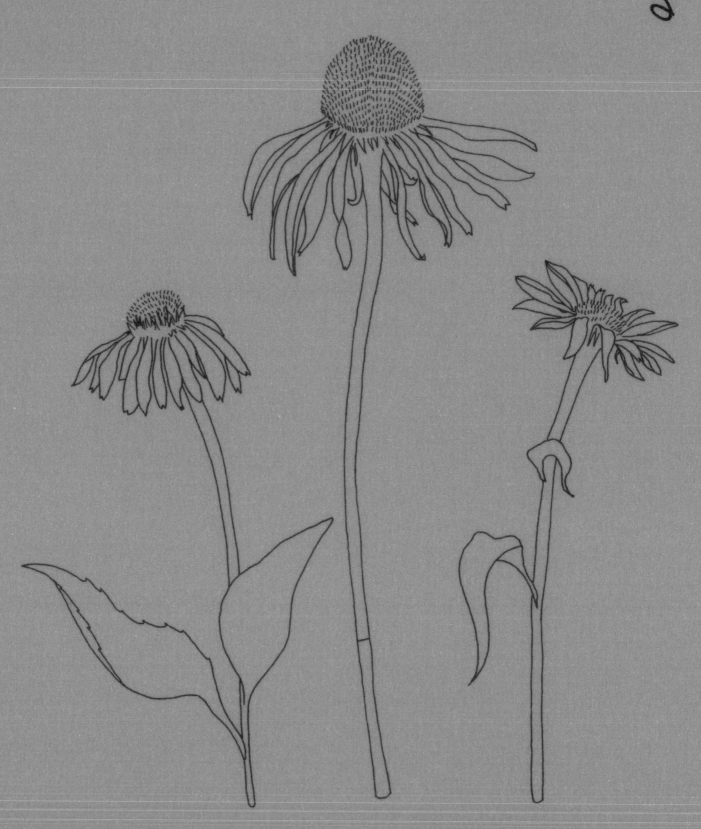

7

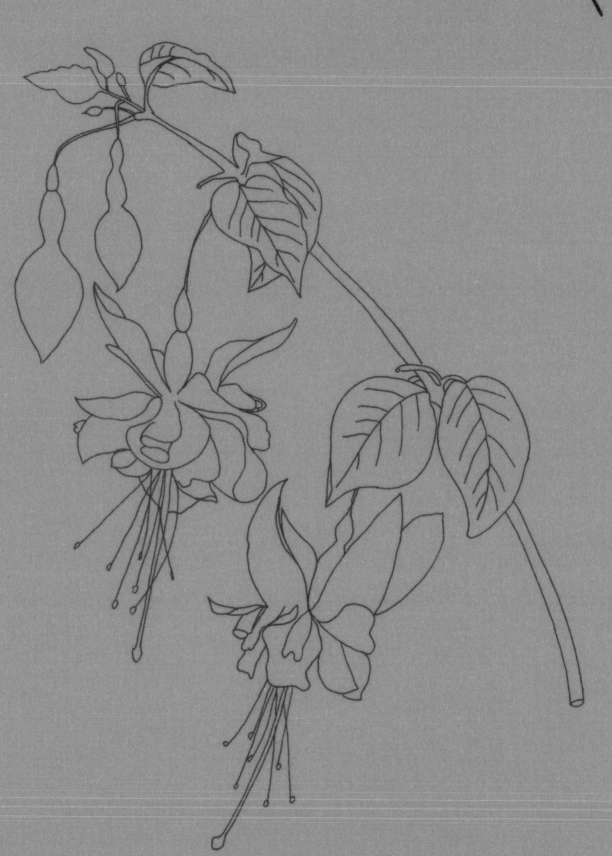

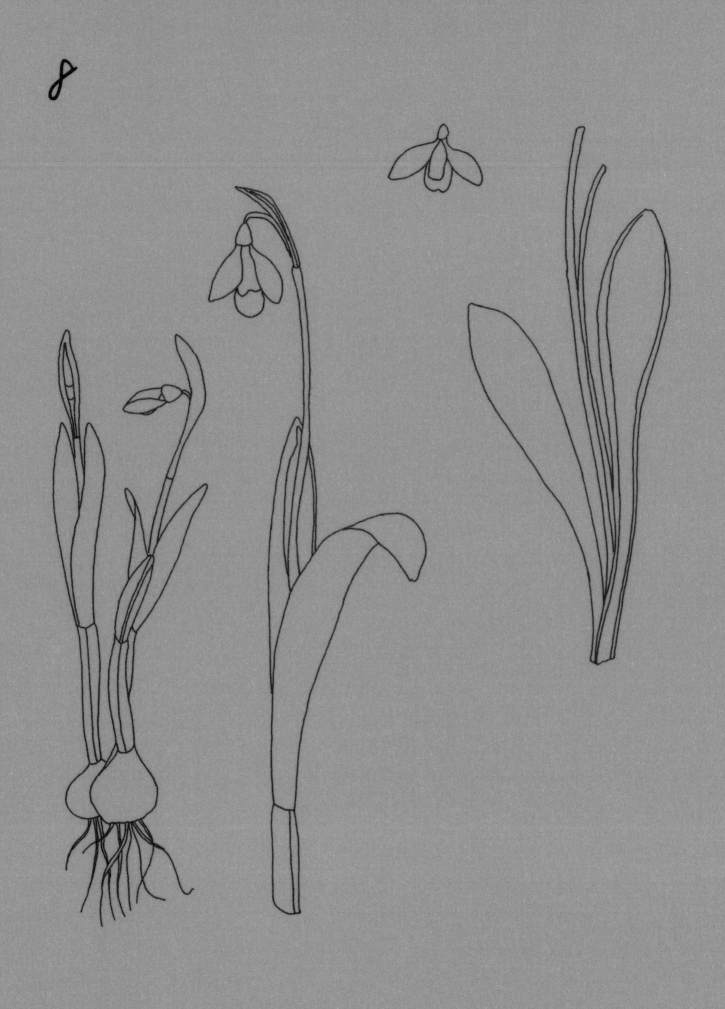

8

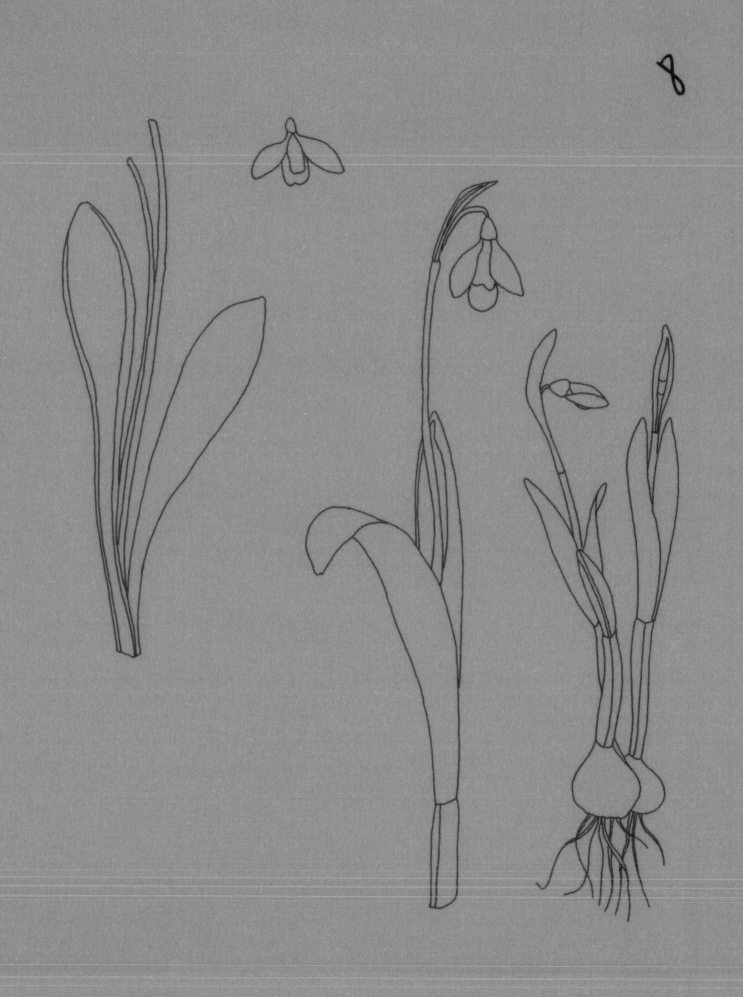

9

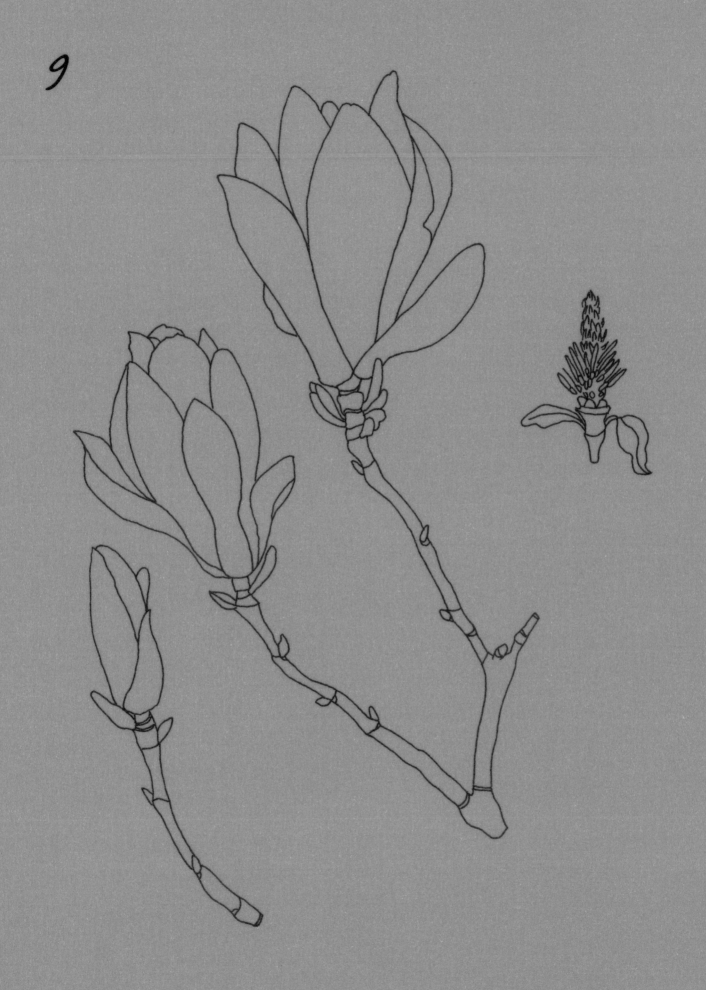

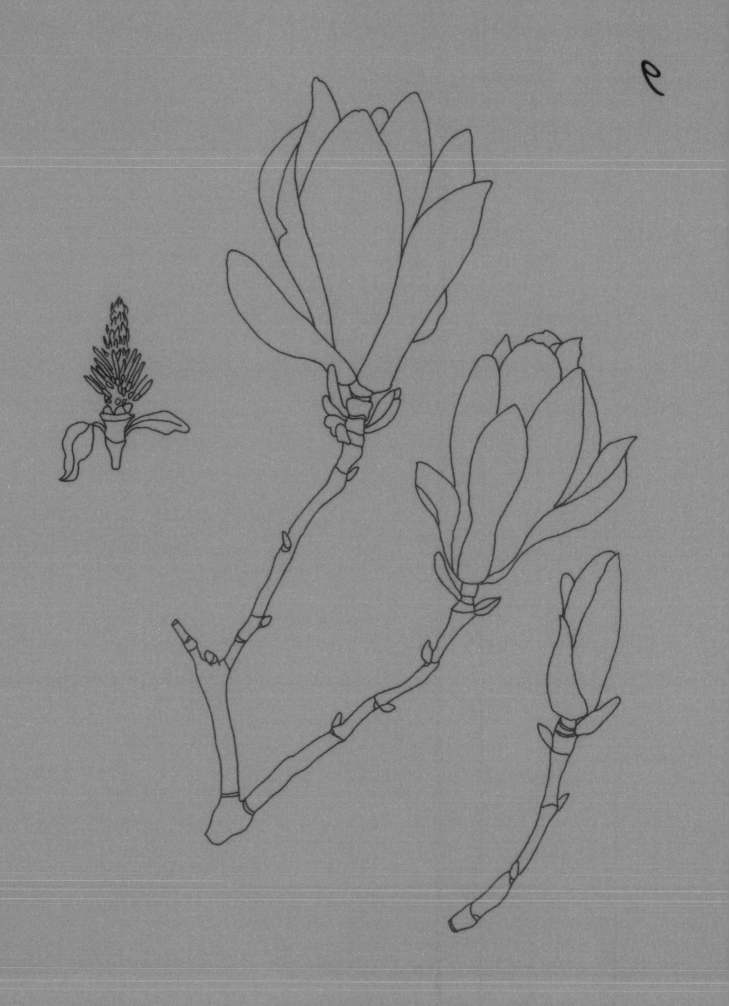

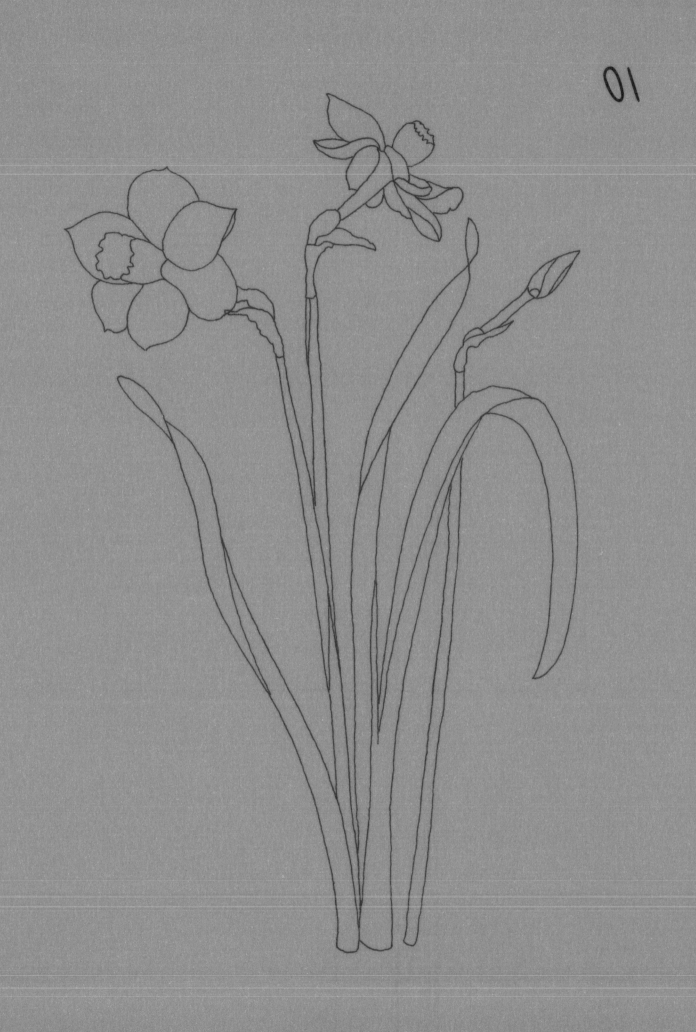

01

11

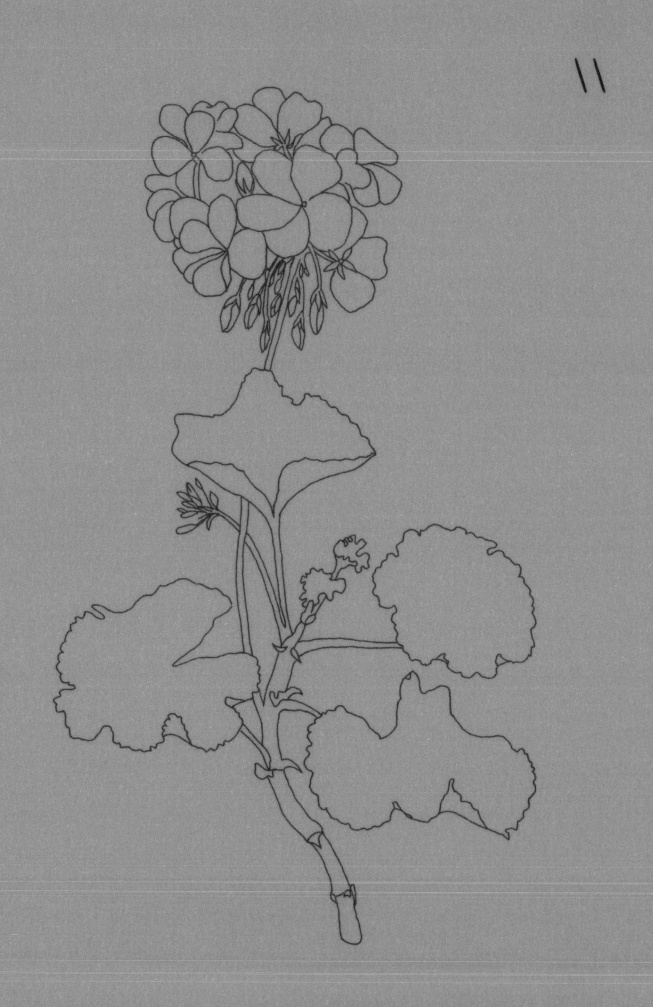

11

12

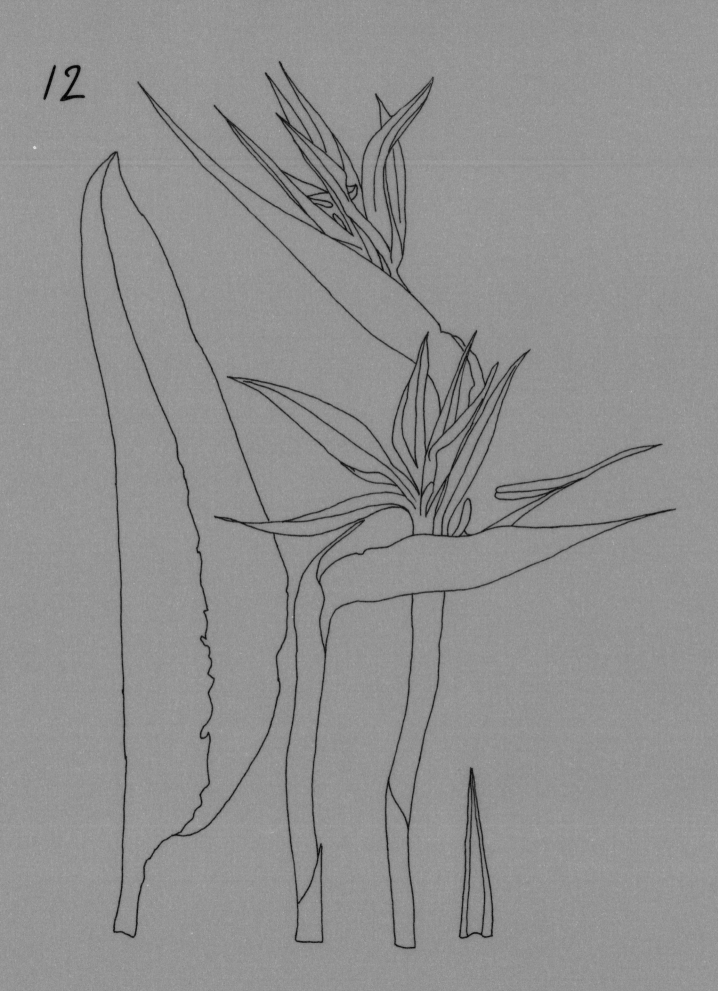

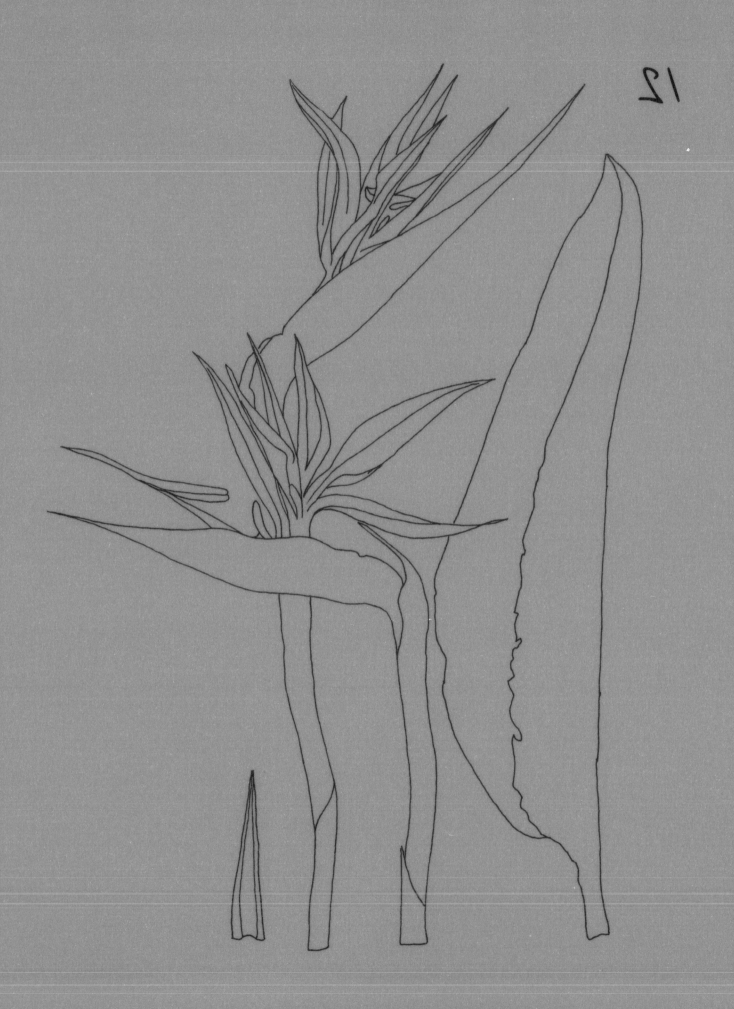

13

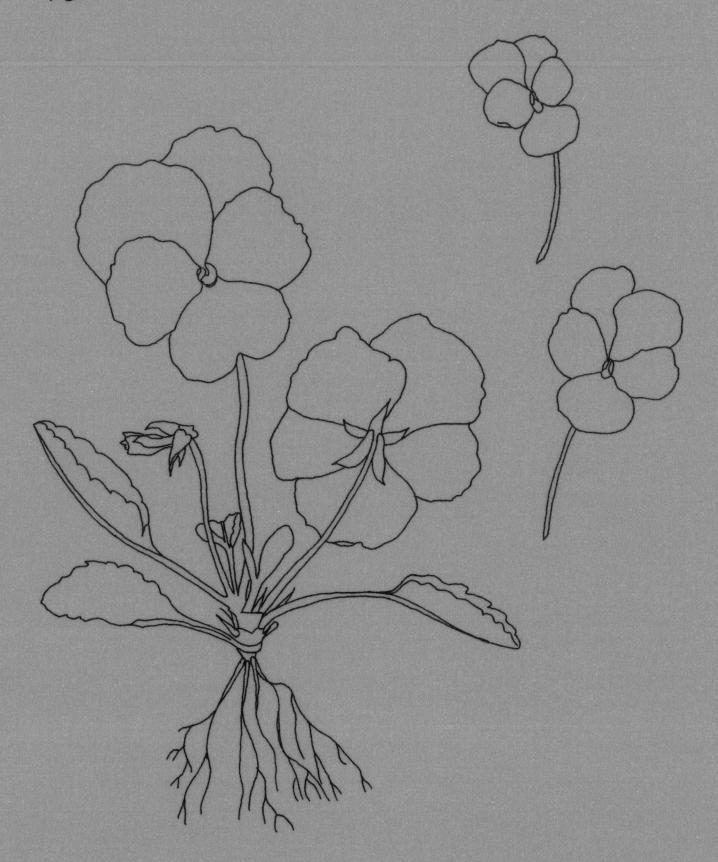

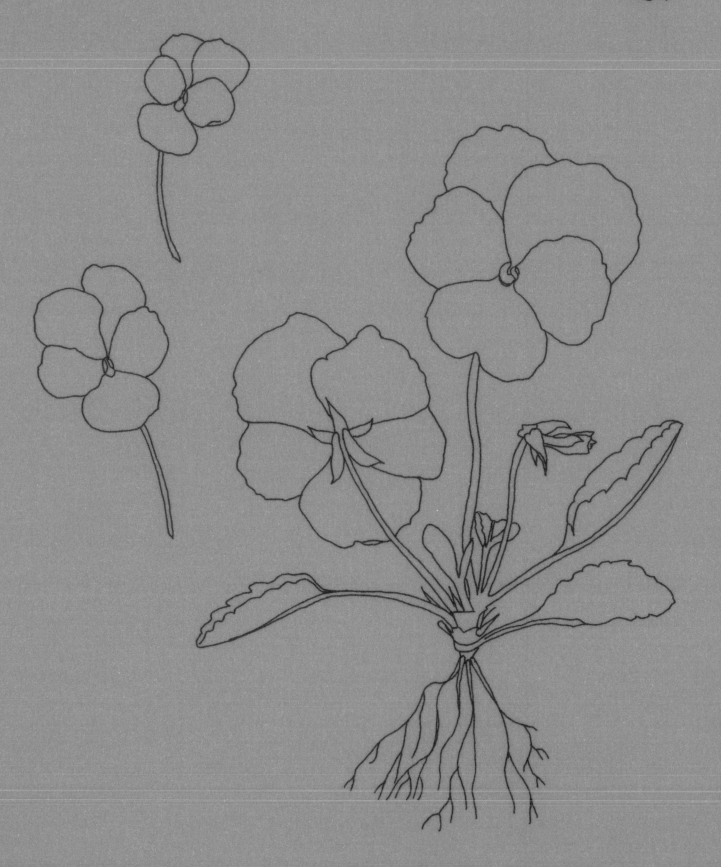

13

14

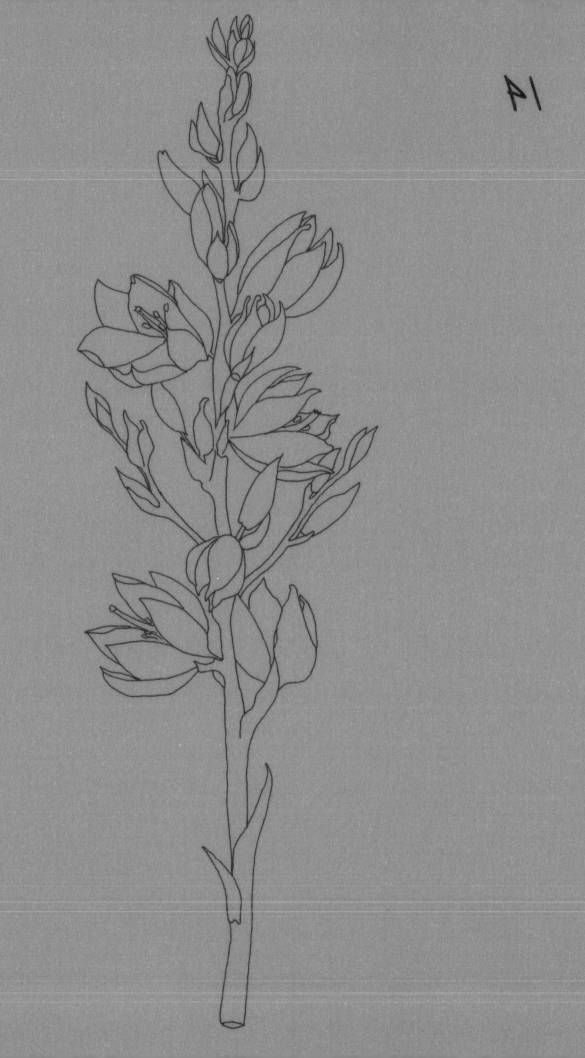

15

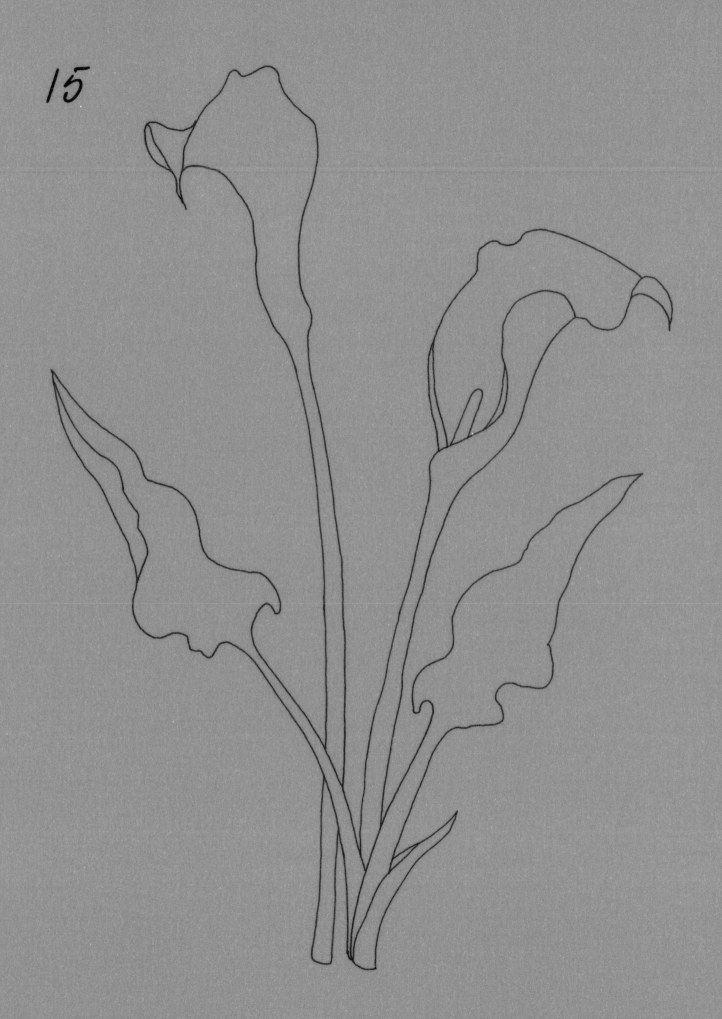

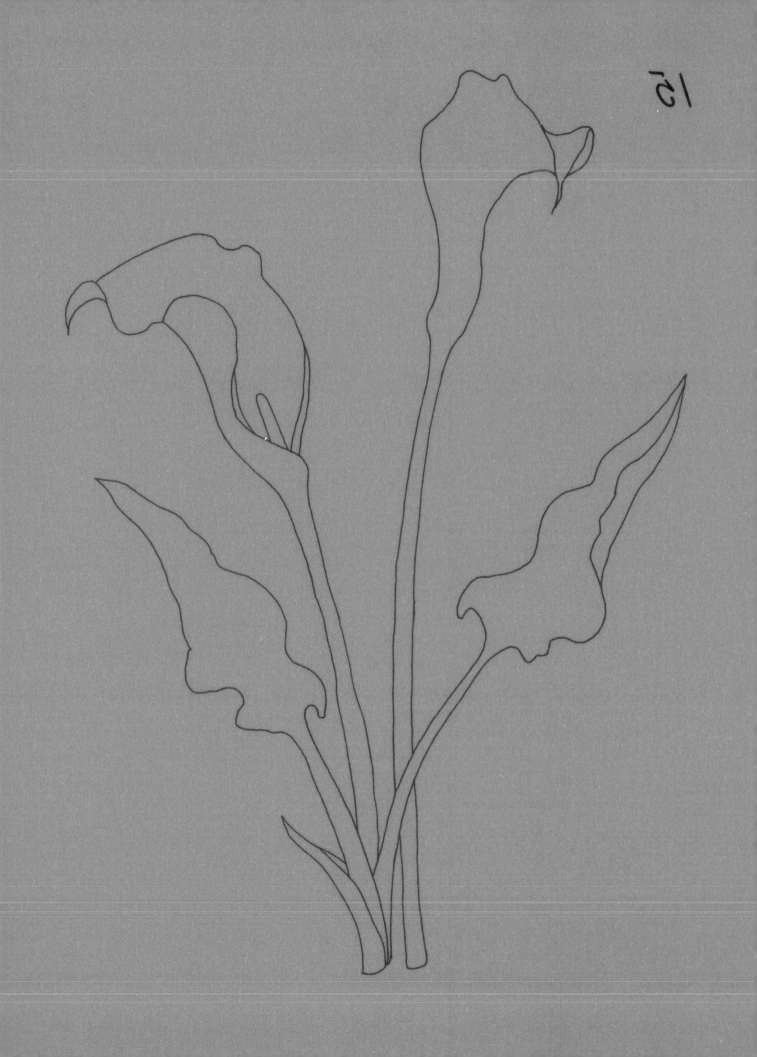

16

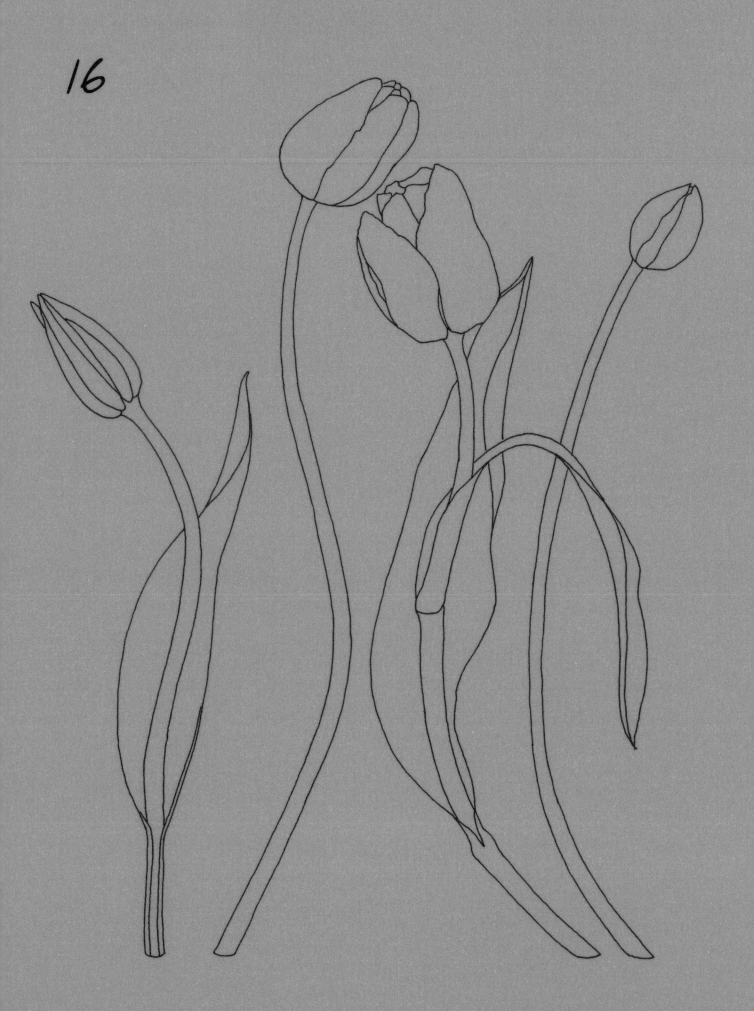

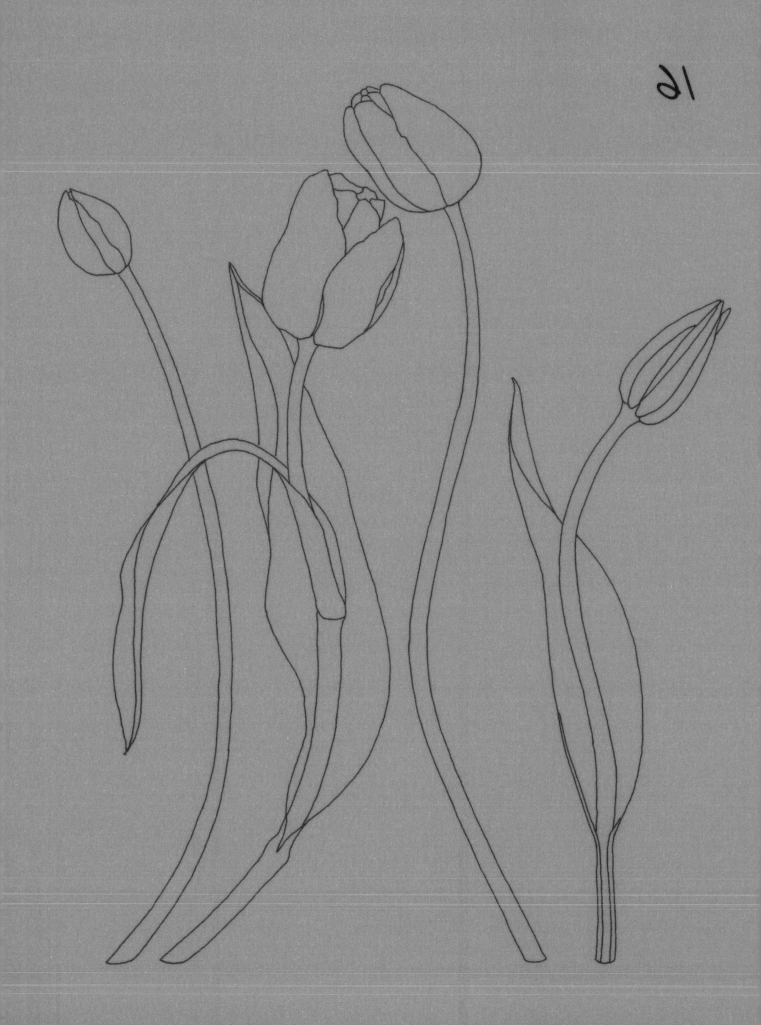

BEGINNER'S GUIDE TO
BOTANICAL
FLOWER
PAINTING

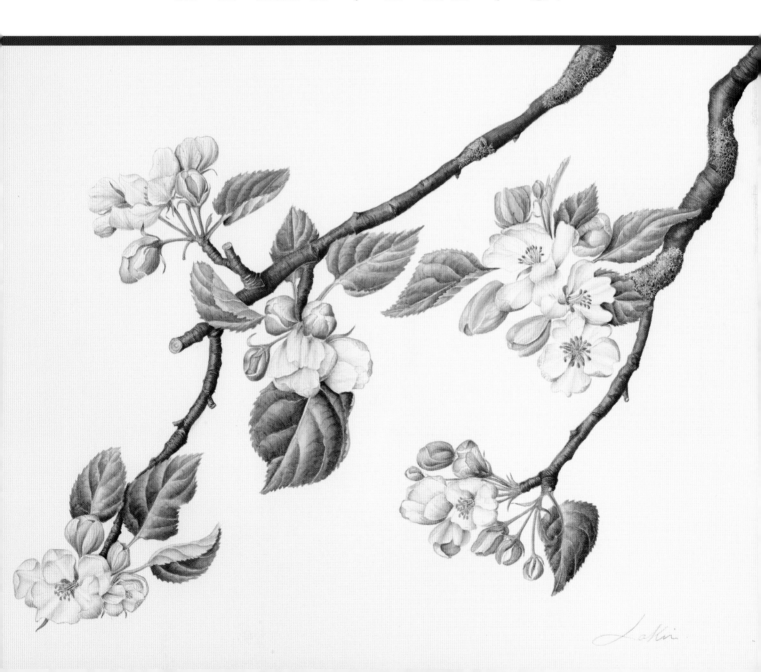

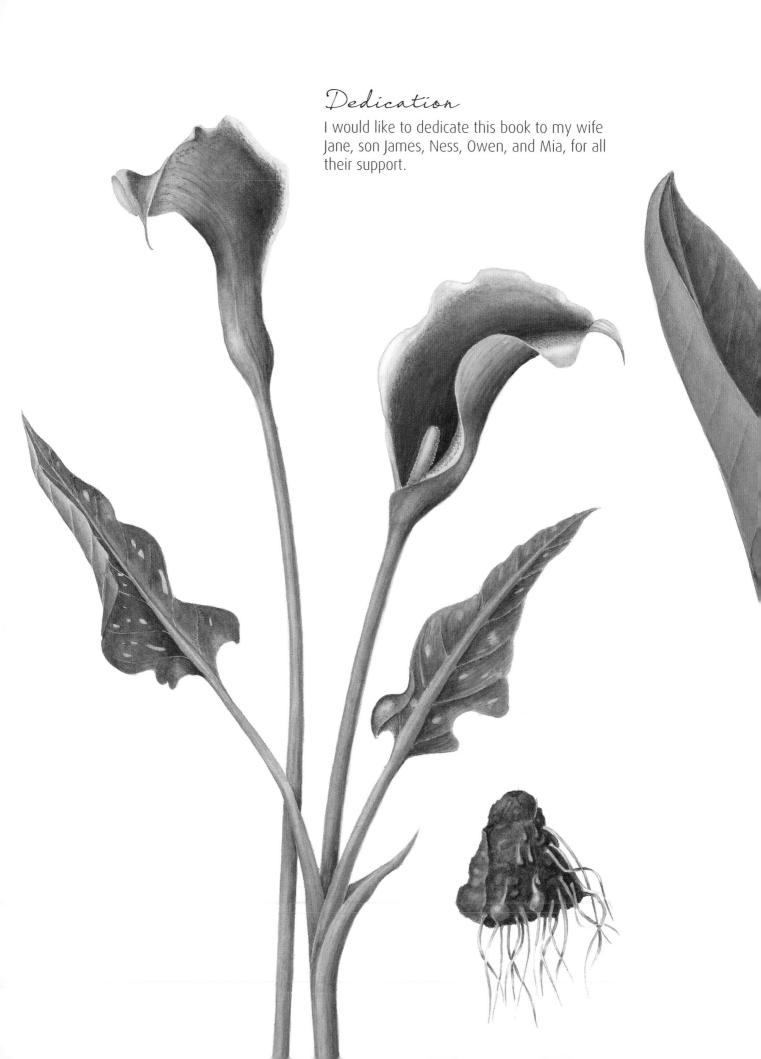

Dedication

I would like to dedicate this book to my wife Jane, son James, Ness, Owen, and Mia, for all their support.

BEGINNER'S GUIDE TO
BOTANICAL
FLOWER
PAINTING

Michael Lakin

SEARCH PRESS

Page 1:

Apple Blossom – 'Newton Wonder'

This apple variety was grown for the first time in Kings Newton, a village in South Derbyshire, UK. This illustration is part of a set I painted for a 2014 exhibition for the RHS (the Royal Horticultural Society), for which I was awarded a silver medal.

Page 2:

Zantedeschia

A South African plant, the calla lily comes in many colours. The flowers range from almost black to nearly pure white, and include yellows, magentas and pinks. The flower was brought to Europe in the first half of the eighteenth century and to England in 1731. This particular variety is 'Picasso'. This painting is accompanied by tracing 15 – you can use this with the techniques in this book to produce your own version.

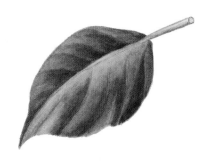

First published in 2017

Search Press Limited
Wellwood, North Farm Road,
Tunbridge Wells, Kent TN2 3DR

Reprinted 2018 (twice), 2019, 2020, 2021

Based on the following books by Michael Lakin, published by Search Press:
Ready to Paint Botanical Flowers in Watercolour, 2010
A–Z of Botanical Flowers in Watercolour, 2012

Text copyright © Michael Lakin 2012, 2017

Photographs by Roddy Paine Photographic Studios, Debbie Patterson, and Paul Bricknell © Search Press Studios

ISBN: 978-1-78221-310-9

Publisher's note
All the step-by-step photographs in this book feature the author, Michael Lakin, demonstrating his watercolour painting techniques. No models have been used.

You are invited to visit Michael's website:
www.michaellalkinart.co.uk

CONTENTS

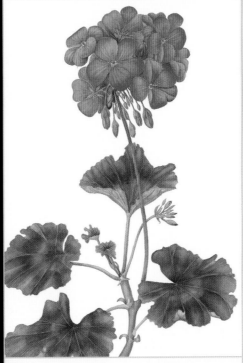

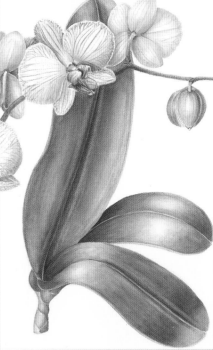

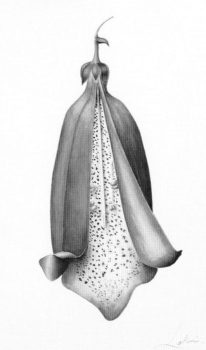

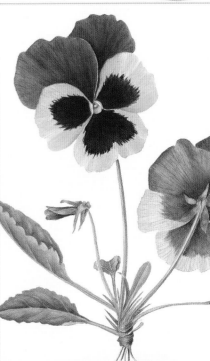

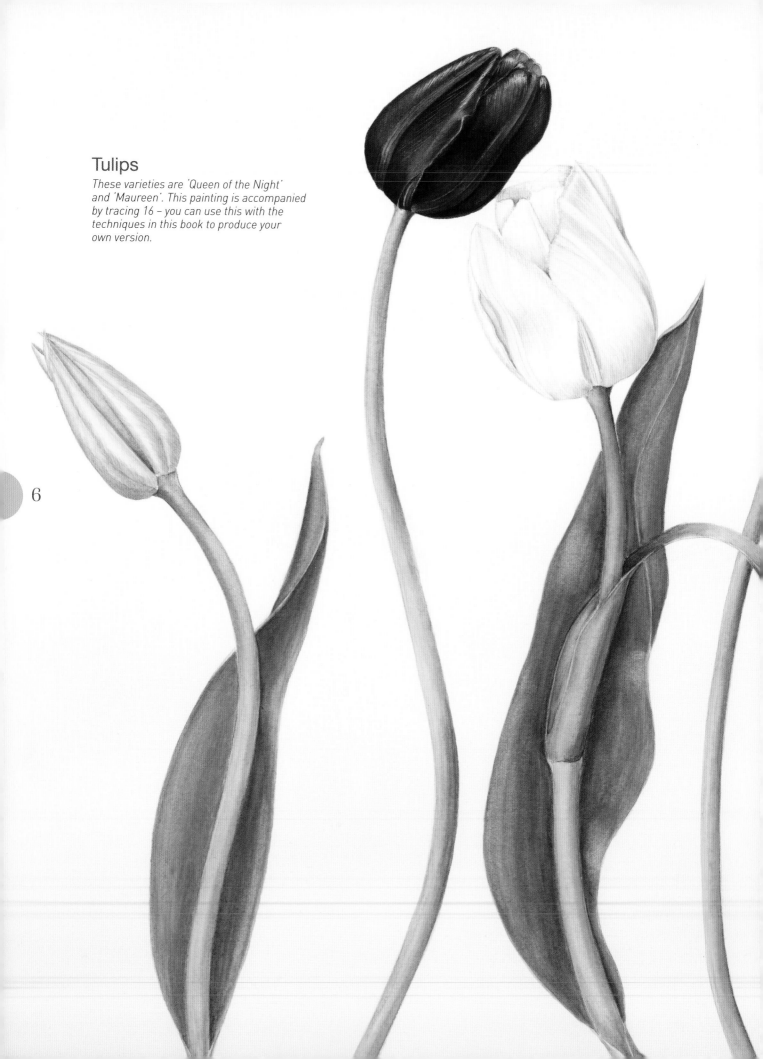

Tulips

These varieties are 'Queen of the Night' and 'Maureen'. This painting is accompanied by tracing 16 – you can use this with the techniques in this book to produce your own version.

6

INTRODUCTION

I have been a tutor of botanical illustration for many years, and people often comment 'I love what you do, but I could not possibly achieve anything like the standard in a million years'. My reply: 'If you have good tuition and the will to succeed, you need only enthusiasm, dedication and time to achieve your goal.' I and many of my students are living proof of this. Understanding the basics and starting with simple, accurately observed drawings is the way forward.

You have to discipline yourself, give yourself time to spend on your artwork. Botanical painting is not the type of art that you can do in one day and forget. You have to work hard and practise the various disciplines needed to achieve good results. For a total beginner to become a competent botanical artist, it can take six to eight years of work and study.

This book is aimed at the beginner to put them on the right track to achieve a good standard of botanical art, and enjoy the same satisfaction as I and my students have over the years.

Materials

When buying art materials for botanical illustration, buy the best. It will pay off in the long run; though ultimately achieving the best results is down to you, not the materials!

Artistic equipment

Paper

My favourite surface on which to work is Hot-Pressed (HP) 100 per cent cotton paper, in a 300gsm (140lb) weight. Hot-pressed means it has a smooth, untextured surface, which allows for the clean, smooth application of paint necessary for botanical art. I find Sennelier A3 size block, 297 × 420mm (11¾ x 16½in), to be the best, as it is easy to store and each piece will be pristine when you come to use it.

Paints

Watercolour paints are available in pans and tubes. I prefer to use half pans. Paint colours can vary slightly from manufacturer to manufacturer – the sap green from one, for example, might not match the sap green from another. For this reason, I use a selection drawn from both Sennelier and Winsor & Newton. I am careful to use a consistent range; replacing each colour as it runs out with another from the correct manufacturer.

Paintbrushes

The most important quality to look for in the brushes you choose is that they keep their point well. I use Raphael 8404 series round brushes, ranging from size 0000 (the smallest) to size 6 (the largest). These are excellent pure sable brushes, which carry plenty of paint.

Pencil

For my initial drawings, I use 0.3mm propelling pencils, as this ensures a consistent line. A conventional pencil will suffice if it is kept sharp. Pencils are available in a number of grades (hardness); HB and H are best for the clean lines necessary in botanical painting.

Brush care

Pure sable brushes are expensive, so it pays to look after them. After you finish a painting session, wash them in cool clean water. Paintbrushes are typically sold with a protective sleeve over the ferrule. Once the brushes are dry, replace the sleeve to protect the point and place them in your storage case or brush box.

Brushes that are well cared-for will last a long time. About twice a year, apply a little hair conditioner to the bristles and rub them gently between your fingers. Rinse them in warm water and then carefully reform the point between your fingers. This will keep them in top condition.

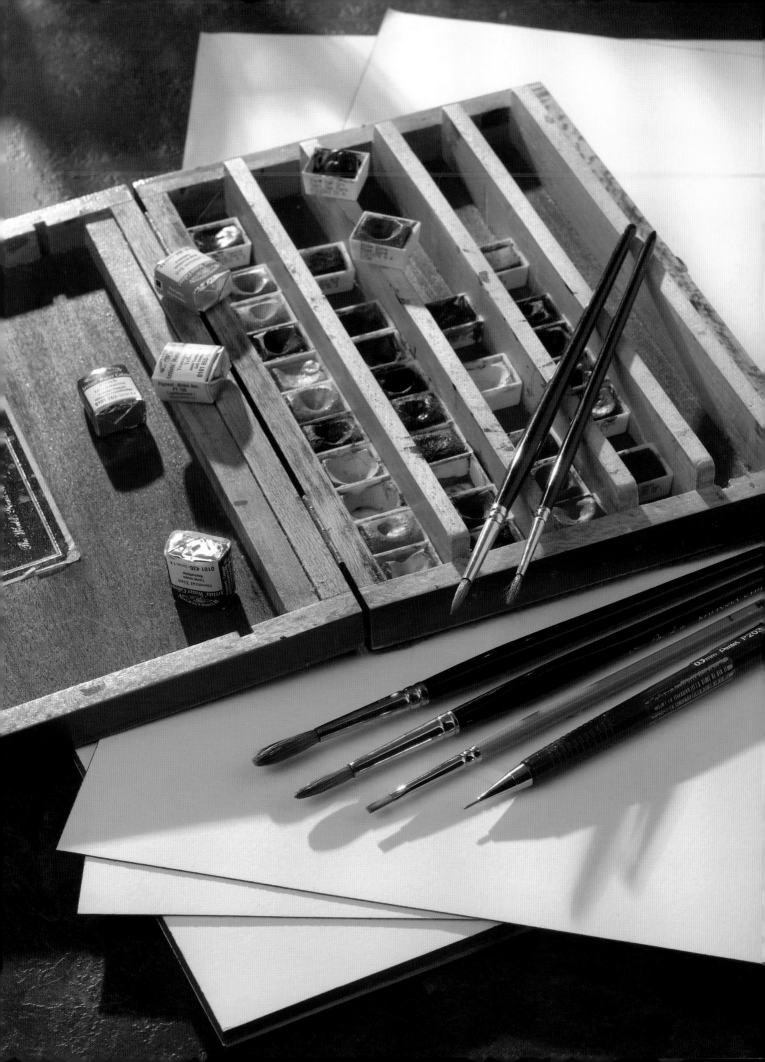

Other equipment

Scalpel This is used for dissecting flowers, seed pods, bulbs and so forth.

Microscope Before drawing small parts of the flower, such as stamens, styles and stigmas, it is useful to use a microscope to better understand their shapes and form.

Scissors A pair of small, sharp embroidery scissors is useful for dissection.

Proportional dividers It is important to measure the components of the subject matter accurately. Dividers are available for scaling up individual parts twofold, threefold or more.

Hair conditioner Because sable brushes are made from animal hair, normal hair conditioner will help to revitalise them and keep them in top condition.

Brush box In order to keep the points of your brushes safe, a brush box should be used.

Masking tape This is used to hold your drawing or painting paper to a drawing slope or board.

Kitchen paper You will find kitchen paper very handy for mopping up excess water from your brush or painting.

Magnifier A handheld magnifier will enable you to see plant material much more closely, while working through a flexible desk-standing magnifier will leave your hands free. Either will allow you to get much more accurate and clean edges to your leaves and petals. Magnifiers with a weighted base and arms that end in crocodile clips are a good alternative. These hold your subject upright while you draw it.

Light box or **tracing paper** You will need one of these to transfer the outline pencil image you produce to Hot-Pressed (HP) watercolour paper.

Putty eraser This can also be used for erasing small amounts of pencil work. Unlike a normal eraser, a putty eraser can be rolled and shaped to carefully remove details from watercolour paper.

Soft eraser An eraser is used for general erasing of pencil lines when producing your initial drawing.

Drawing fluid Sometimes you will have areas that need to be left as clean white paper, such as veins, stigmas and stamens. Drawing fluid, also known as masking fluid, can be used to protect these details while you work the surrounding areas.

Mapping pen This is used to apply drawing fluid to the paper.

Cartridge paper This is usually available in pads, and is used to produce the initial drawing.

Tweezers A very useful tool for removing and holding individual components of a flower during dissection, these will help you to get a clearer view of petals, sepals and other small parts of the flower.

Shading pencils HB and H pencils are used with the continuous tone method of shading (see pages 28–29) to create form in your sketchbook. Use a pencil sharpener to keep them sharp.

Water containers Two water pots are needed: one for mixing colours and cleaning your brush, and one kept clean for grading your paint on the paper.

Ceramic palettes Ceramic palettes are useful for mixing your paints to the correct colour.

Drawing slope Drawing and painting should be enjoyable, and a drawing slope or board will ensure that you remain comfortable while you work.

Digital camera An invaluable tool, this allows you to take pictures and review them, in order to quickly get compositional references for your work.

Anglepoise lamp I suggest using a posable lamp with a daylight bulb, as these provide the best, most accurate light.

Fineliner pen A pen with a fine nib (I recommend a 0.3mm nib) is used for outlining your sketch, making it easy to transfer.

Water phial Water phials hold a small amount of water. They are useful to ensure your subject does not wilt while it is held upright for drawing.

Clamp An adjustable clamp will let you position your flower securely while you work.

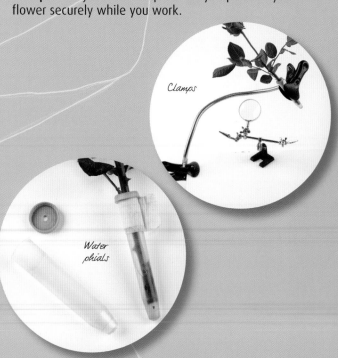

Clamps

Water phials

10

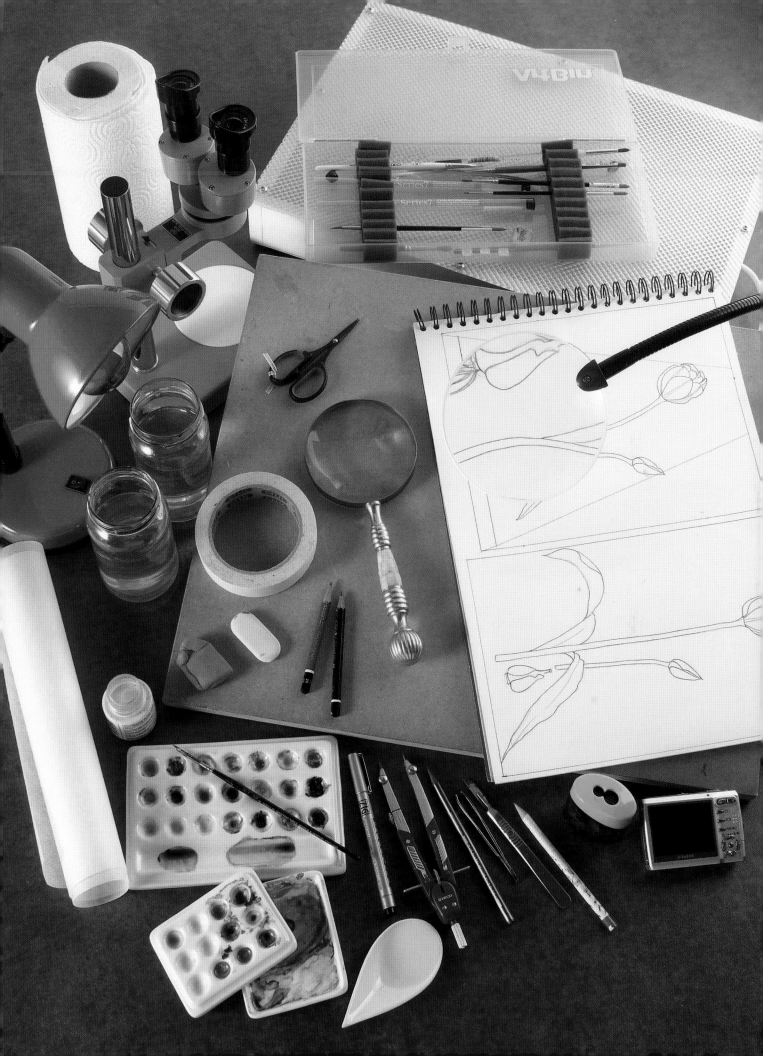

Viola sp.

*Unlike most of my botanical work, which is produced
at life size, this unusual example was painted at three
times its actual size. This compositional choice gives a
more striking effect and allows a closer look at the subtle
detailing and colouring of the isolated flowerhead.*

Preparing your flower

When choosing your subject it is good practice to have an idea of the composition you would eventually like to produce. Sometimes this can be as nature intended it to be, worked exactly as it appears; and sometimes it can benefit from a few adjustments.

Finding a suitable plant

A traditional botanical illustration should include a full flower, a bud (or buds), the back of the flower, and both the front and underside of the leaves. Overcrowding of the stems should be avoided.

With these considerations in mind, choose a good example of your chosen subject (i.e. healthy, undamaged and representative of the type of plant), cut it carefully, and place it in water.

The flower can be kept in a refrigerator to keep it cool and fresh. You can use a lamp to open a bud or bring a flower further into bloom.

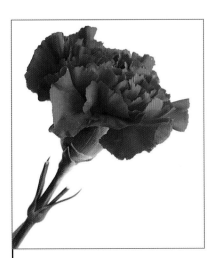

A suitable specimen

This carnation is an excellent example of a suitable subject to draw and paint because it is complete and fresh-looking. It also shows all of the important components such as calyx, sepals and new leaf growth.

An unsuitable specimen

In contrast, this carnation is a poor example: the petals are misshapen, and some are torn and damaged. In addition, some important components of the flower cannot be seen. A good botanical illustration has a variety of shapes and colours – these are not evident in this example, so it will produce a lacklustre final piece.

Wildflowers

Wildflowers are protected by the law in many parts of the world. If they are to be drawn and painted, permission from the landowner must first be obtained. In addition, you should check the latest updates concerning wildflowers in your area; do not just pick them. When choosing a subject, pick only a small amount, and replant them when you have finished painting the flower.

Familiarising yourself with the subject

When you have decided upon the flower that you wish to draw and paint, study it well. Observe the shape of the petals and sepals, and note how they fit to the stem. Decide whether the leaves are equal or varied in size, shape and texture. You should make notes as you observe, as they can act as handy memory aids when you return to the studio.

Dissection

Dissecting and breaking a flower down into its component parts is most important for the botanical artist as it will help you understand the construction of the flower and how it fits together. In turn, paying attention to how they fit together will help the artist to draw them accurately.

 The sketch of the dissected plant (opposite) illustrates which parts are particularly important for you to study. It illustrates how a dissection allows you to see parts of the flower that are hidden; as well as showing how the parts interact with each other.

Tip

Place the petals, stigmas, stamens, nectaries and other individual parts onto a piece of white card, so as to see the correct shapes when drawing them.

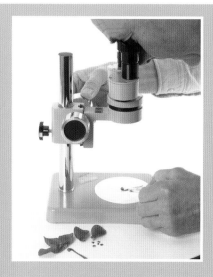

14

Close study

A microscope will enhance the artist's ability to study particularly small components, and will help with the understanding of the plant. In turn, this will lead to an enhanced study and finished flower portrait.

 Once you have completed your dissection, place the individual components under the microscope one at a time. Adjust the focus until you have a clear image, then make further notes. You will find it useful to make some drawings or sketches of these details, as this provides invaluable practice.

To make this dissection, I used a scalpel, a pair of tweezers, a small pair of pointed scissors, a clean piece of white paper and a microscope.

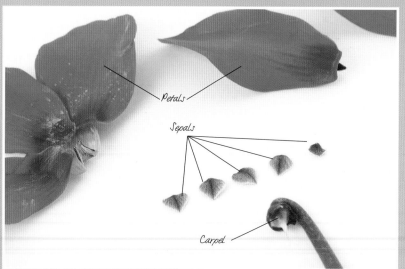

The petals, sepals, stamen and carpel were separated from the stem, with care taken to ensure that the parts remained intact.

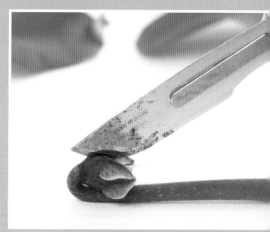

With the other main parts removed, the stem was cut in half to examine the internal structure. I took care to ensure that the cuts were clean.

Structure of the flower

The sepals (the five small green-purple structures on the right of this picture) are slightly tougher petal-like structures which protect the bud before the flower opens. When the flower opens, they are commonly hidden under or behind the larger petals (the large pink-purple parts on the left and top of this picture). Note that the sepals are larger and more colourful than the petals in some flowers. In the example below, the petals are sketched at life size, while the sepals are sketched at twice their actual size.

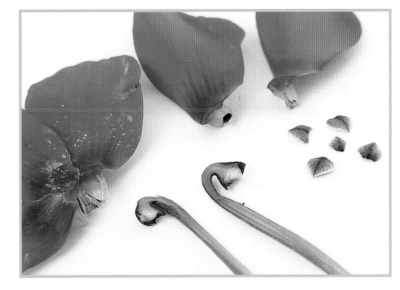

The stamens are the pollen-producing male part of the flower, and some can be seen on the left-hand side, at the centre of the three petals. Note the scattered dust-like yellow pollen towards the centre of the petals. Because the stamens in this example are markedly different on the inside and outside, I made separate reference sketches.

At the end of the stem is the carpel, the female part of the plant which produces the fruiting body after pollination. Both the stamen and carpel are very small, so I sketched them at five times their actual size.

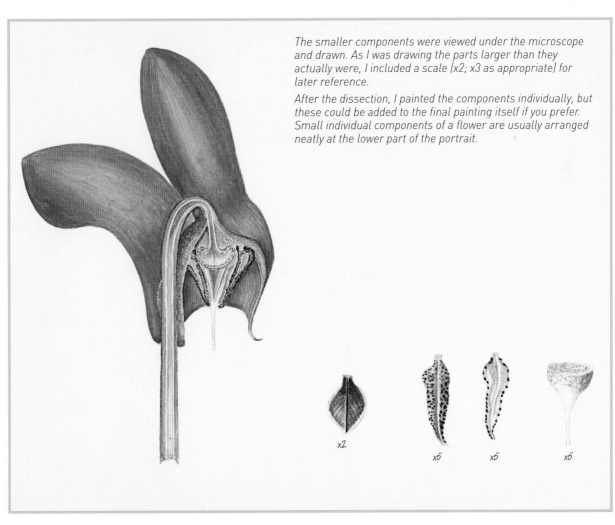

The smaller components were viewed under the microscope and drawn. As I was drawing the parts larger than they actually were, I included a scale (x2; x3 as appropriate) for later reference.

After the dissection, I painted the components individually, but these could be added to the final painting itself if you prefer. Small individual components of a flower are usually arranged neatly at the lower part of the portrait.

x2

x5　　x5　　x5

Composition

Once you are familiar with the plant, you can begin to work out how you want to compose your painting – that is, how you arrange the flower in order to draw it. The basic composition of a painting will usually spring to the artist's mind as soon as the subject matter is seen, but it is worth taking time to think through the specific relationship of the components with each other.

Arranging your work

When you have chosen your subject, place it in water, then look to see the best angle from which to draw the plant. Try moving it around, taking it out of the water and replacing it, and making small adjustments until you are content.

Sitting with the plant at eye level will give you the best all-round view of your subject. Do not place the plant at the side of you – it is much easier to have it directly in front of you, so you do not need to keep turning to look at it.

Source of light

Always organise one light source. Place it above and to the left of the plant if you are right-handed, and above and to the right of the plan if you are left-handed.

What should be in the picture?

Deciding what should go into the final composition is a very broad subject, but to achieve a professional result, it is important that all of the preparation work for the composition of your final painting should be done in your sketchbook before you begin on your watercolour paper.

In addition to the basic elements (a full flower and its back, the front and underside of the leaves and a bud), you may wish to include other interesting or distinctive parts, such as the root system, old leaves or seedpods (see page 61 for a good example).

Decide whether the subject is going to be life-sized or scaled to fit the paper you are using. Plants with large leaves, very tall stems or those that are very broad/tall can sometimes go off the page. In these instances, you may wish to have only some of the leaves/stem visible in the picture, in order that other parts are shown sufficiently large. Alternatively, you can show separate details in your composition, such as in the foxglove on page 51, where the base of the stem is shown separately to the top.

Leading on from this consideration is whether you wish to include a detail of any dissected parts. This can be very useful to show the inside of the fruiting bodies, roots and other details.

If you decide to include many small components, draw them in the sketchbook individually. These can then be traced separately, which allows you to experiment with different arrangements in your composition before you finalise it.

Finally, I recommend that you ask someone else's opinion of your composition before you transfer it to watercolour paper. An external perspective can offer valuable insights, and prevent any oversights that you have missed by being so closely involved.

Tip

Avoid even numbers in your compositions. Including odd numbers of leaves, flowers, buds and stems is more visually pleasing.

Tip

You will find making a small thumbnail sketch in one corner of the sketchbook is very useful, as this will show whether the basic shapes work well when stripped of the details.

Negative space

Negative spaces are the areas in between the shapes (i.e. the components of the flower; the 'positive shapes') placed on your surface. When the components are placed correctly, the negative shapes of the clean white paper set off the positive shapes of the painted components to form the complete picture.

Remember that the negative spaces you leave bring balance to the composition when you are sketching your image. If you leave too little negative space, the finished painting will look crowded and busy. If you leave too much, the subject will look lost on the paper.

The composition triangle

The composition triangle is a simple method of producing a pleasing composition. Imagine an isosceles triangle on your paper and place the main bulk of the plant within the triangle. The components of the plant subject do not have to fall completely within the triangle lines, merely comply roughly with its shape. The shape of the triangle will vary depending on the plant you choose to paint, and it is only a guideline – do not feel restricted by the triangle. In fact, letting a few parts of the plant escape the triangle adds a sense of natural life to the composition.

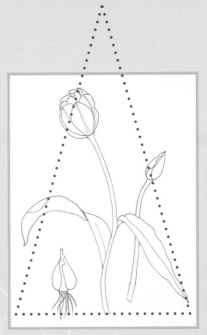

An example of the composition triangle. Note that the top part of the triangle meets outside the frame, and that some important parts of the composition like the bud on the left-hand side sit outside it.

17

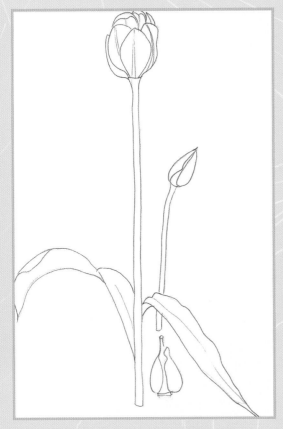

This composition is unsuccessful because the stem is far too tall and straight, leading the eye out of the picture. The main flower is too far away from the rest of the composition, and the bulb is crammed into a small space. Too much negative space has been left, and no margin has been left for framing.

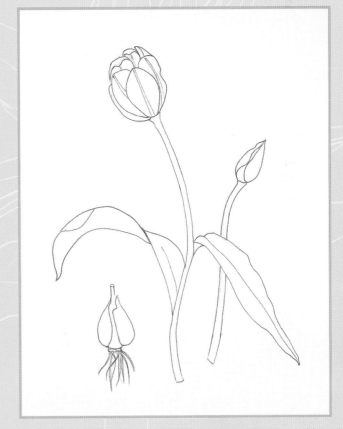

This revised composition is successful because the composition is well balanced. Your eye moves around the image, with equal weight being given to each of the components. The additional bud and stem complement the main flower, mirroring the curve in its stem, and the bulb is in a more pleasing position on the lower left, where it fills a large gap without drawing too much attention from the main flower.

Drawing

Before starting to draw, it is important to have a good understanding of your subject. Observe it well, and relate the shapes of the petals and leaves to each other, as well as the negative shapes between them. Remember, a good drawing is vital to a successful finished painting.

Starting to draw

Before starting to draw select the correct grades of pencil, H and HB, and make sure that they are sharp. Use good quality smooth paper, no lower than 190gsm (90lbs), and at least A3 – that is, 297 x 420mm (11¾ x 16½in) – in size.

Draw various simple shapes of flowers, leaves and seedheads. Practise flowing lines for strap leaves and stems; let yourself go. It does not matter if you make mistakes; you have an eraser. We all rub out at some stage. The following pages look at some common geometric shapes – cups, circles and the like – that relate to the shapes of flowers. By practising these simple shapes, you will start to recognise them in the more complex forms of the flowers.

Keep your pencil on the paper and make continuous reference to the flower in front of you: look, then draw; look–draw; look–draw. Do not be taken in by all the detail. Look at the basic shape; detail can be introduced at a later stage. Just keep practising. You will improve!

Flower shapes

Flowers come in a bewildering array of shapes and sizes – as demonstrated on the facing page. This can be intimidating. However, most flowers can be reduced to simple shapes to get the basic size and proportions correct before you develop the details. Geometric shapes are the basic form of many flowers, and the following pages give you some approaches to make drawing even complex flowers very simple.

18

Your working area

The ideal setup for botanical art is as follows: place a small table and chair to the right-hand side of a window (if right-handed, or opposite if left-handed). Use a sloping drawing board approximately 50 x 40cm (20 x 16in) set with all your equipment – paints, palette, water pots and so forth – to one side of the drawing board. An adjustable lamp with a daylight bulb is also advisable. Make sure that you are comfortable, as sitting for two to three hours can be painful on the neck and back once you have set up.

Your subject matter should be placed in front of you at eye level to get the optimum viewpoint of the subject. If they are cut specimens, place them in water. A white card or board at the back of the subjects is advisable as this will make all edges of the plant crisp and sharp. After working on your subject, always cover it up as insects, etc. could foul the paper.

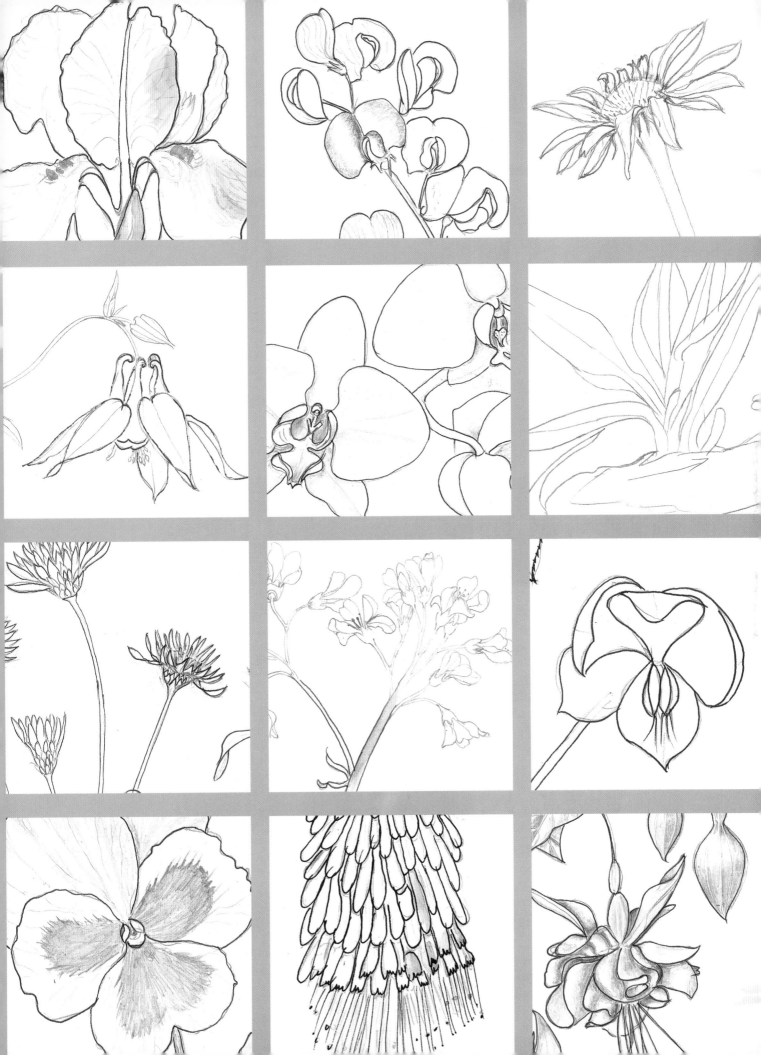

Examples of flowers based on the cup

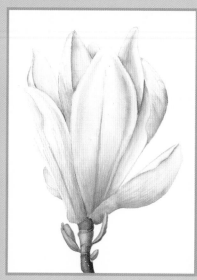

The cup

The simple cup shape provides the basic form of flowers like open tulips, roses and many more. Practise drawing cups in various sizes, then try closing in the vertical lines towards the top of the cup and adding some petals. This will allow you to draw cup-shaped flowers in various states of blooming.

It is always a good idea to use a live specimen to look at, as petal positions change from variety to variety. Draw in the centre petal, then add the two outer petals before adding the final ones.

Using the cup shape

The example below shows how a cup shape can be developed into a flower – in this example, a tulip.

Inverted cup

The fritillary is based on an inverted cup so the same process applies: the petals are added gradually over the basic shape.

Drawing from a cup shape

This simple example will make drawing even an apparently complex rose very simple, by basing it on the cup shape.

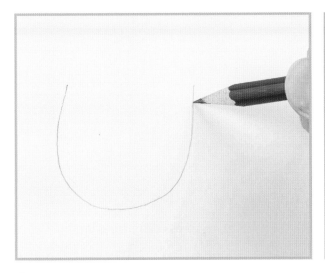

1 Using a sharp HB pencil, draw the basic geometric shape – in this case, a cup. Even at this stage, you need to look at the source flower in order to make sure you get the angle and relative size correct.

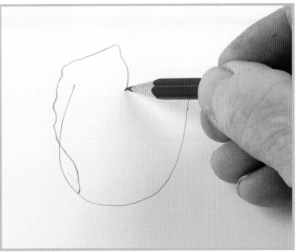

2 Identify the first petal, starting from the leftmost. Begin to draw it using considered single lines – do not sketch or scribble – and work until the petal ends or is hidden; keep paying attention to the source image. Look and draw; look and draw.

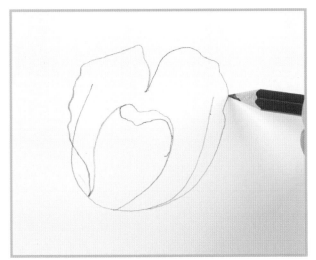

3 When you reach the end of the petal, pause and check the shape and size are correct. Move on to the next one, and use the basic cup shape and previous petal to help guide your placement.

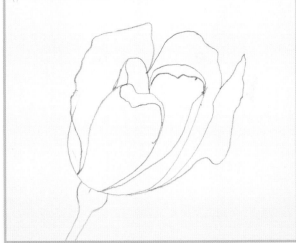

4 Continue working to the right. Once all the petals are in place, the original cup lines can be erased using a solid natural rubber eraser or a putty eraser.

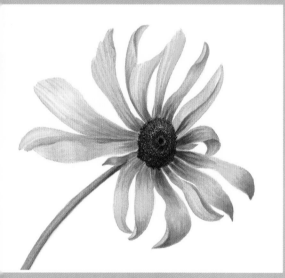

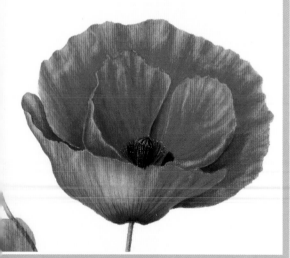

The circle

The circle is the basic shape of many flowerheads, including all the daisy family, dahlias and daffodils. Start by drawing the circle, then simply place the various petal shapes around it. The centre seedhead or trumpet will also follow the circle or ellipse shape.

Using the circle

When viewed from other angles, the circle will become an ellipse. In the example below, the height of the circle stays the same, but the width gets gradually narrower depending on the angle required. In any case, the principle of placing the petals around the circle remains the same. Bear in mind that the petals will appear different lengths and shapes from different angles.

Multiple circles

This daffodil uses two circles – a larger one for the petals (biologically, these are actually sepals), and a smaller one for the trumpet. While these appear superimposed when viewed face on, note that the smaller one needs to move away from the centre of the larger as the daffodil head turns away, until it entirely separates, as shown below right. It remains joined to the rest of the flowerhead by the trumpet.

Drawing from an ellipse

If drawing composite (multi-petalled) flowers, quarter the circle or ellipse so as to make it easier to fit in the many petals. You will notice that the petals appear to get shorter on one side through a process called foreshortening.

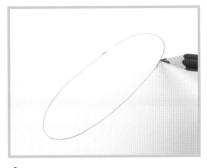

1 When drawing an ellipse, confidence is key. Try and draw it with your sharp pencil in one smooth stroke. You can always erase and redraw if necessary.

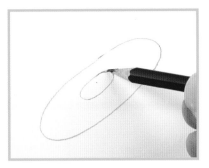

2 Put a smaller ellipse slightly left of the centre; this will be the centre of the flower. Note that the two ellipses sit at similar angles.

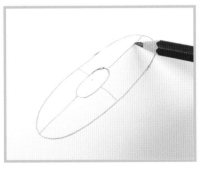

3 Quarter the flower with faint lines that run from the edge of the outer ellipse to the inner ellipse. These will help you judge how many petals fit in each quarter, and prevent you bunching them or having awkward gaps.

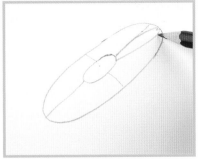

4 Keeping your work neat and working with single lines, draw the petals confidently, making them fit between the edges of the two ellipses, so the base of each one is touching the central ellipse and the tip of each is touching the outer ellipse. This will naturally create foreshortening.

5 Work all the way round. Note that not all of the petals are equal in size or identical in shape, so do pay careful attention to your subject matter.

6 When adding the stem, ensure that it emerges from behind the central ellipse.

7 Paying careful attention to the centre of the flower, draw in the shapes here. These are generally circular, but some are slightly irregular. You need to observe the flower carefully to get the most realistic result.

Examples of flowers based on the cone

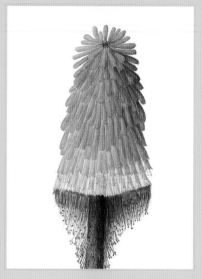

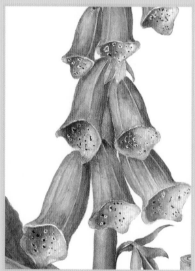

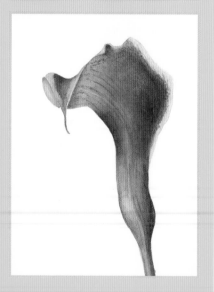

The cone

The cone shape shown here is common to the foxglove, penstemon, bluebell and many others. After drawing this basic cone shape, add the stem and petals. Depending on the angle at which you are looking at the cone, the stigma and stamens may be visible, and can also be added.

The basic cone shape is only a little more complex than the circle and cup, but if you pay careful attention to ensuring the basic shapes are correct, accurate flower images will soon follow.

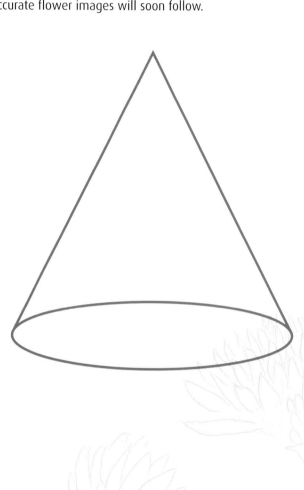

The column

The column, in various lengths and widths, forms the basic shape of stems. Practise drawing them with horizontal and vertical bends and curves in them, as this practice will be invaluable.

The column is the first step into drawing stems, branches and similar shapes. Start with the main stem, adding the smaller side stems as required. Again, practise many until you perfect the correct shapes.

When drawing stems of any kind, draw one line first, then draw another line at the side of it. When adding in the second line, ensure that you keep the same distance from the first along the whole length.

Examples of stems based on the column

25

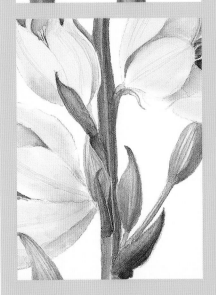

Drawing leaves

When drawing leaves, start with the midrib: this is the centre vein of the leaf. Draw the leaf shapes using single clean lines, rather than sketching them. The more lines you make, the messier the leaf will look. Keep margin lines thin and accurate. When drawing serrations, make sure you have observed the leaf well, as serrations come in many shapes and sizes. Similarly, when drawing veins, note that the ones on the front of the leaf differ from the ones on the back of the leaf. Also observe that veins can emerge from the midrib in pairs, or alternating.

For the beginner problems arise when the leaf, or part of the leaf, is twisted or has a fold inwards or outwards. The solution is to make sure that if the fold was opened out if would form the complete shape. Practise all the shapes of the leaves in your sketchbook.

Shading the leaves will be performed in the same way as the flowers, which is detailed on pages 30 and 31.

Drawing a leaf from the front

No two leaves are the same, and because you rarely view them face-on in botanical flower painting, they will rarely appear symmetrical. As with the flowerheads, look, then draw. Keep referring to the plant in front of you, and draw what you see, not what you think you ought to see.

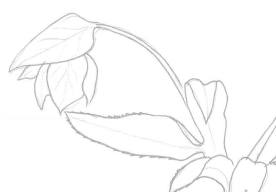

1 The midrib will determine the overall shape of the leaf. Draw two lines that meet at one end, and become slightly more distant at the base. This base is the petiole, where the leaf meets the stem.

2 The margin of the leaf can now be drawn in. Pay careful attention to the width of your leaf; careful observation before each side is drawn in will yield the best results.

3 Add the fine sideveins. Note that the subsidiary veins either alternate with each other where they join the midrib, or will be paired.

Drawing a folded leaf

A common problem for many beginners is drawing folded leaves, as the curve and shape can be confusing.

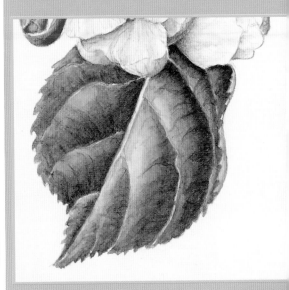

1 The best way to approach drawing curved leaves is to draw the leaf as accurately as you can.

2 Next, add a faint guideline outside the folded leaf that is the same size as the open side.

3 You can now visually identify if the leaf, when unfolded, would fit into the faint space. If not, you need to adjust the drawing before continuing.

This example is incorrect – if unfolded, the leaf would not reach the guideline.

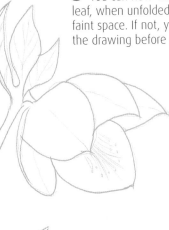

Tone

Continuous tone shading is particularly well suited to botanical work as the gradation from dark to light is both gradual and subtle. The lines or dots created by other tonal methods, such as cross-hatching or stippling, could be mistaken for texture on a petal or venation on a leaf that is not present in the specimen.

First and foremost, a tonal drawing is an aid towards your painting. When you identify the form with the tonal work in your sketchbook, then the petals, leaves and stems that make up the image will have a three-dimensional look. This will give you direction and confidence when you come to the painting process.

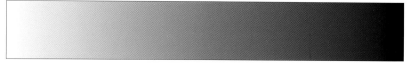

This band shows a neutral grey tone like that produced with a graphite pencil, from the lightest-toned tints on the left, to the deepest shades on the right. Regardless of the hue of a colour, the tone can be light or dark.

28

Ellipses

Continuous tone is made up of many small ellipses drawn with your pencil. The movement should originate from the shoulder, not the wrist. After practising for a while you will begin to understand why care should be taken to fill the grain of the paper and not leave empty ellipses.

The exaggerated example on the left shows how the ellipses should be overlapped. The right-hand image is enlarged only slightly, and it shows how the individual ellipses blend into one another, covering all of the surface texture of the paper. The tone is altered by changing the pressure you place on the pencil: the more pressure you use, the darker the tone. Note that light-toned areas still have the same number of ellipses: they are just very faint.

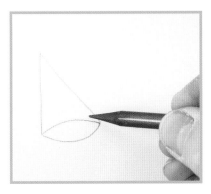

1 With an HB pencil, identify the area furthest from the light source. In this case, it is on the outside of the cone at the bottom left.

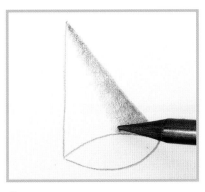

2 Start making tiny overlapping ellipses and gradually reduce the pressure on the pencil as you work towards the lighter areas, paying careful attention to the shape's surface and adjusting the pressure.

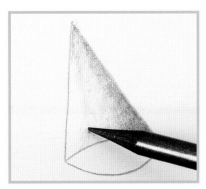

3 Continue working across the shape, reducing the pressure almost to nothing in the lightest areas. Remember that you are still creating the same size ellipses: they are simply so faint as to be nearly unnoticeable.

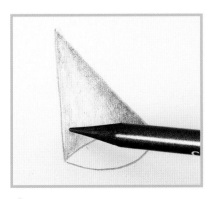

4 As you work past the highlight area, increase the pressure again to darken the tone.

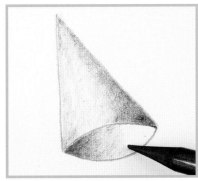

5 Once you have finished one area of the shape, repeat the process on the other areas in turn. In this example, adding shading on the left-hand side of the base suggests the cone is hollow.

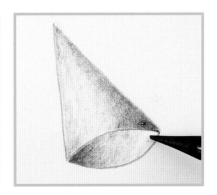

6 Continue creating the overlapped ellipses, altering the pressure to change the tone until you cover the entire surface of the object.

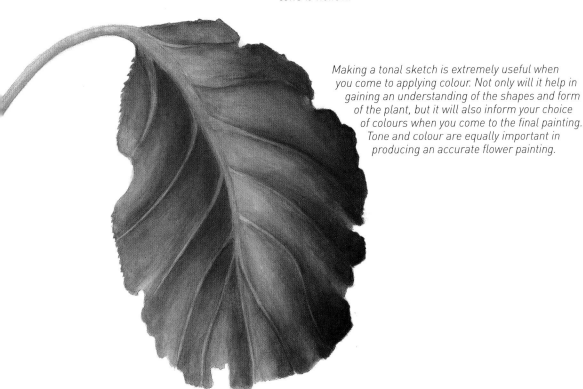

Making a tonal sketch is extremely useful when you come to applying colour. Not only will it help in gaining an understanding of the shapes and form of the plant, but it will also inform your choice of colours when you come to the final painting. Tone and colour are equally important in producing an accurate flower painting.

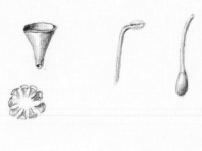

Concave hellebore petal

Convex hellebore petal

Smaller parts of the
hellebore flower

Shading on flowers

The parts of flowers – the petals,
stamens and so forth that we looked
at when dissecting our specimen –
are more complex in form than the
simple cone on the previous page.
However, the same principles apply
when applying shading. The aim is to
give them shape and form with the
continuous tone method.

Rather than tackling the whole
flowerhead, which can be intimidating
for a beginner, try drawing and shading
the individual components.

The petal of the dissected hellebore
shown above is illustrated both concave
(the front) and convex (the back) – the
effect is achieved in the same way for
each, but with different areas shaded to
create the impression of form.

The concave appearance of the front
of the petal is created by shaded very
darkly on the the left-hand side, grading
to almost white on the right-hand side.
The same applies to the small stem of
the petal.

For the concave back of the petal,
start by shading the right-hand side,
leave the centre part almost white, then
shade the left-hand side slightly, leaving
it darker than the centre, but not as dark
as the right-hand side.

The small components are shaded
in the same way. If good gradation
is performed, the parts will look
three-dimensional.

Having successfully shaded the
components, draw the complete
flowerhead as shown in the centre of
the page. Shade the whole flower in the
same way, working around the stamens,
stigmas, and other components, then try
the poppy flower.

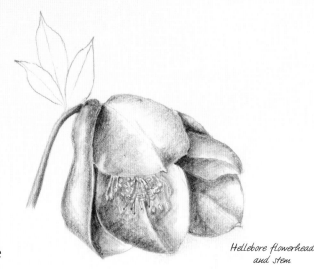
Hellebore flowerhead
and stem

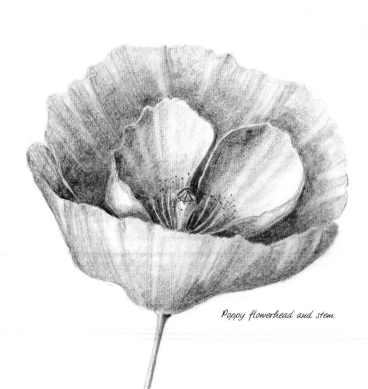
Poppy flowerhead and stem

30

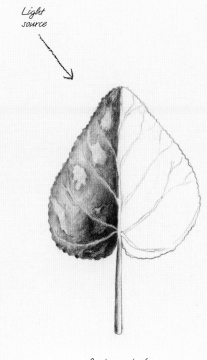

Light
source

Cyclamen leaf

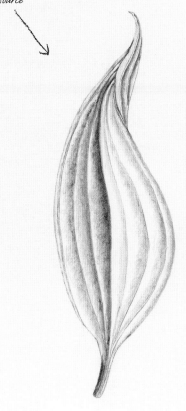

Light
source

Hosta leaf

Light
source

Daffodil leaf

31

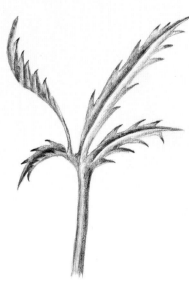

Light
source

Field poppy leaf

Shading the leaves

The same method used for shading the flowers is used for the leaves, too: continuous tone. The examples on this page show some of the variety of leaf shapes and textures for you to practise drawing and shading.

Having drawn the leaf, start shading in the darkest area. This will depend on the position of the light source – the darkest areas will be directly opposite the light. For these examples, with the light sources at the top left, the darkest shadow will be at the bottom right.

Work around the veins if they are lighter than the leaf colour, or put them in later (by overlaying) if darker. Any light patterned areas should be drawn in, then worked around. If the leaf has a dip in the middle, then the darkest area is one the left of the midrib. If you can see the back of the leaf, the veins are shaded on the right so as to make them stand out.

To obtain surface modelling, as on the hosta leaf, draw in the vertical veins, then add shadow from right to left, grading as you go.

From flower to drawing

The following pages walk you through the preparatory procedure for your botanical painting, from picking the flower to matching the colours.

Preparing the flower

1 Pick a nice colourful bunch, with plenty of variety. This, for example, contains zinnias (the large orange flowers), carnations (the purply-pink), roses in bud, small yellow chrysanthemums, blue statis, and small green chrysanthemums.

2 Select a single flower – in this case one of the zinnia blooms. This is a composite flower and similar to the drawings we have made on page 23. Choose the best specimen – look for an example with good shape, good colour and good symmetry.

Compare this poorer example: while the colour is still vibrant and intense, the shape is slightly distorted and it is not particularly symmetrical.

32

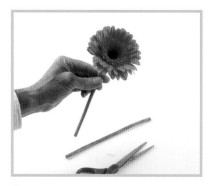

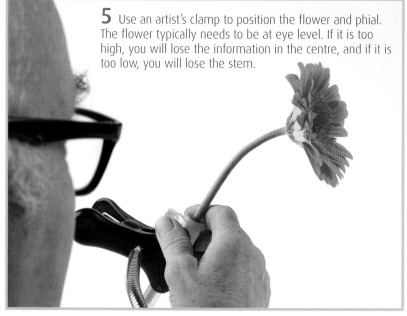

5 Use an artist's clamp to position the flower and phial. The flower typically needs to be at eye level. If it is too high, you will lose the information in the centre, and if it is too low, you will lose the stem.

3 Having selected a good flower, you now need to get it ready to use as your source material. Trim it to length – you need the stem to be stable.

4 Fill a florist's phial with fresh clean water and then insert the flower.

Tip

When positioning the flower, you are looking to position the flower to make an attractive picture, without compromising the natural position of the flower – an upright stem like this zinnia would look odd if held horizontally, for example.

Creating your drawing

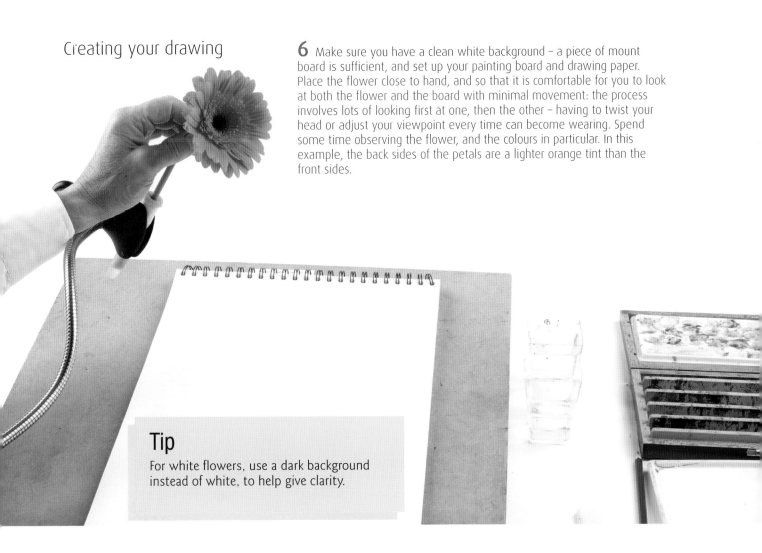

6 Make sure you have a clean white background – a piece of mount board is sufficient, and set up your painting board and drawing paper. Place the flower close to hand, and so that it is comfortable for you to look at both the flower and the board with minimal movement: the process involves lots of looking first at one, then the other – having to twist your head or adjust your viewpoint every time can become wearing. Spend some time observing the flower, and the colours in particular. In this example, the back sides of the petals are a lighter orange tint than the front sides.

Tip
For white flowers, use a dark background instead of white, to help give clarity.

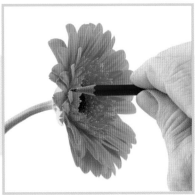

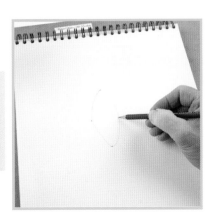

7 Using a sharp HB pencil, make measurements of the dimensions of the flower as it appears to you from your viewpoint. While the flower appears circular when viewed face-on, from the angle at which I am sitting, the width is much less than the height.

8 Make a few guidemarks to get the measurements on to your drawing paper – this is important because botanical illustration is traditionally done at life size. Leave plenty of space around the flower – work near the centre if possible, with large margins.

9 Start to build up the basic shapes with the sharp pencil. Make continual reference to the flower. Look and then draw; then look again before going any further. This is the best way to ensure accuracy.

10 Gradually build up the details. You may wish to fix or ignore any minor imperfections; but be disciplined – you want to draw this flower, not an imaginary 'perfect' one. This is part of the artist's skill – judging how much to refine to give the best representation, and how much to be brutally honest.

11 Refer to the flower at every stage for every detail, and draw exactly what you see. Nature throws up some surprising shapes – the curve of the petals, for example, is obvious when you see it, but it is challenging to translate into two dimensions. Make sure you are drawing the shapes you see, and not what you think is there.

12 Continue until you are happy with the drawing.

13 Transfer the image to watercolour paper using either of the techniques described on the facing page.

14 Make sure all the lines are transferred cleanly by comparing it with both your original drawing and the flower, then use a putty eraser to soften the lines a little. Roll the eraser over the flower to take away some of the graphite, until the image is only barely visible. A balance must be struck between you being able to see the detail while you paint the flower, and making sure as little pencil as possible is visible in the finished painting.

Transferring the image

When the drawing is completely finished, you will need to transfer the image to watercolour paper, using a light box or tracing paper. The processes for each method are shown below.

Using a 0.3mm fineliner pen to strengthen the sketch will help you when tracing it through the watercolour paper.

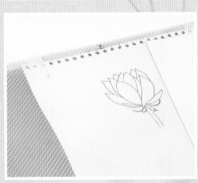

Using a light box

1 Tape your drawing to the light box at the top left- and right-hand corners.

2 Place your watercolour paper on top of the drawing and tape it in place along the top edge.

3 Using an H pencil, trace your image through the paper.

4 Carefully remove the watercolour paper, then compare the transferred image to the original drawing to check you have transferred everything across correctly.

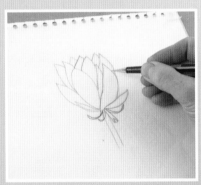
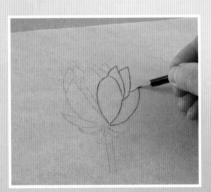
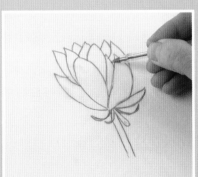

Using tracing paper

1 Use masking tape to secure your drawing to a drawing board at the top left- and right-hand corners, then tape tracing paper over the top. Use an HB pencil to trace the picture.

2 Remove the tracing paper and turn it over. Trace the image on the reverse using a 3B pencil.

3 Turn the tracing paper over again, secure it to your watercolour paper and go over the lines using a dry ballpoint pen.

4 Once finished, you should lift the tracing paper to check that you have transferred everything correctly before carefully removing the tracing paper.

Matching colours

With the drawing complete and transferred, it is time to prepare your paints. When preparing colours, aim to mix as few colours together as possible, to avoid introducing impurities – using too many colours can quickly give muddy results. This short exercise shows you how to use spare paper to make colour matching strips for convenient colour matching.

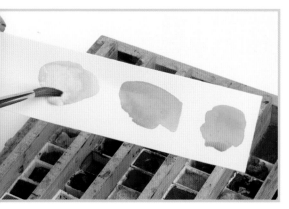 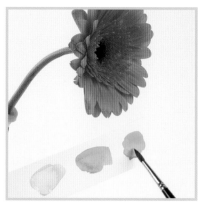

1 The starting point of any mix should be the nearest colour in your palette. Look at the flower and your palette, and paint a small swatch of the nearest colours on to a spare piece of paper. This is your colour matching strip and should be the same sort of watercolour paper as your drawing is on – the colour and texture of the paper can affect the finished colour.

2 Hold the colour matching strip up to the flower and identify the swatch that is closest in colour to the part of the flower you are matching – Winsor orange for the petals, in this example.

3 Look closely at the flower and work out what you need to add to the first colour. In this example the zinnia is a little more red than Winsor orange. Wet your mixing brush and transfer a little of the first colour to your palette.

5 Rinse your brush and pick up a little of your second colour (Sennelier red, in this example). Mix a little into the first colour on your palette.

4 Choose the nearest colour that you think will work to alter the first colour to the correct hue. It may not, but since you are preparing only a small mix, this is not a problem. Colour choice will come with experience, but a good start is by perseverance and with reference to the flower. Here, we want to pick a red. Some of the reds in the palette will clearly be wrong; so pick the nearest.

6 Paint the mix on to a colour matching strip and hold it up to your flower.

7 If the mix is correct, prepare a large amount of the mix. Make sure the hue remains correct, and that it is all even.

Not a match?

If the mix is not correct, then add a small amount of the component colour to bring it closer to the true hue. In this example, if I had added too much red, I would add more orange to bring it back to orange. If it were not red enough, I would add more red. Work gradually – it is best to add tiny amounts to gradually adjust the mix.

8 Pick up the concentrated colour from your mixing palette and wipe it on the edge of a small well of your painting palette to deposit the mix.

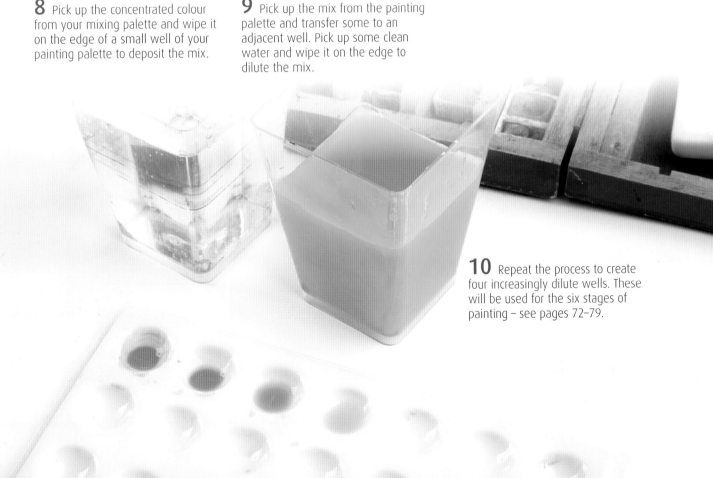

9 Pick up the mix from the painting palette and transfer some to an adjacent well. Pick up some clean water and wipe it on the edge to dilute the mix.

10 Repeat the process to create four increasingly dilute wells. These will be used for the six stages of painting – see pages 72–79.

Using colour

You must become familiar with your own watercolour box. I prefer to use half pans, which I always place in the same position in the box for easy reference.

My palette

The swatches on these pages show the colours in my paint box. Some I use quite often, and others are used less regularly. However, each has its place in my artwork. Even if used only rarely, some colours are perfect for producing the hues of certain flowers.

As well as their unique hue, each paint has qualities that make it more or less useful for certain applications. These are transparency, permanence, temperature and whether it granulates or not. These qualities are noted below each of the paint swatches here.

Transparency Transparent paints allow some of the underlying colour or paper to show through, which creates luminosity and depth of colour. In contrast, opaque colours give flatter washes that cover more solidly.

Permanence Permanent paints are lightfast and will not fade, while others may shift slightly. Bear this in mind when framing and hanging your work.

Temperature Cool colours tend to recede, and warm colours appear to advance towards the viewer. Bear this in mind when composing your picture to create depth. Combining a warm colour with a cool colour will create a less intense mix than two warm or two cool colours.

Granulation When dry, granulating colours will have visible grains of pigment, which can add an interesting texture.

White gouache
Opaque, permanent and neutral. Gouache colours have heavier pigment which makes them more opaque than watercolour paints.

Cadmium yellow
Opaque, permanent and warm.

French ultramarine
Transparent, permanent and warm. Granulating.

Alizarin crimson
Transparent, moderately durable and cool.

Sap green
Transparent, permanent and cool.

Cadmium orange
Opaque, permanent and warm.

Permanent mauve
Semi-transparent, permanent and warm. Granulating.

Cadmium red
Opaque, permanent and warm. Granulating.

Transparent yellow
Transparent, permanent and cool.

Neutral tint
Opaque, permanent and cool.

Permanent magenta
Transparent, permanent and warm.

Burnt sienna
Transparent, extremely permanent and warm.

Prussian blue
Transparent, permanent and cool.

Manganese blue
Semi-opaque, permanent and cool. Granulating.

Raw umber
Transparent, extremely permanent and cool. Granulating.

Payne's gray
Semi-opaque, permanent and cool.

Winsor red deep
Semi-opaque, permanent and warm.

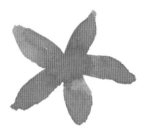

Opera rose
Semi-transparent, permanent and warm.

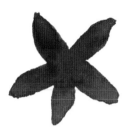

Winsor violet
Transparent, permanent and warm.

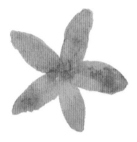

Rose doré
Transparent, permanent and warm.

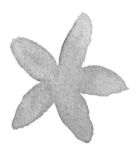

Winsor blue (green shade)
Transparent, permanent and cool.

Olive green
Transparent, permanent and cool.

New gamboge yellow
Semi-transparent, permanent and warm.

Yellow ochre
Semi-opaque, extremely permanent and warm.

Winsor yellow
Semi-transparent, permanent and warm.

Winsor green (yellow shade)
Transparent, permanent and warm.

Aureolin
Transparent, permanent and warm.

Permanent sap green
Transparent, permanent and cool. This permanent version of sap green is from the Sennelier range.

**Winsor green
(blue shade)**
Transparent, permanent and cool.

Winsor lemon
Semi-transparent, permanent and cool.

Lemon yellow
*Opaque, extremely permanent and
cool. Granulating.*

Mixing colours

The colours listed here provide a good range of colours, but to get realistic results, you must combine them and produce your own mixes to match the flower in front of you. Becoming proficient at this will take time, so practise mixing colour charts (see page 44) with different combinations of colours to familiarise yourself with the properties of each paint, and be careful to keep your paints clean. Mix in a white palette in order to keep the colours true.

Colour matching strips

Colour matching strips, as seen on pages 36–37, are a great way to practise mixing colours to match a particular area of the plant. They are simply offcuts or strips of spare paper onto which you paint a sample of your mix. This enables you to bring a sample of the colour directly to the plant, for easy comparison. It is important to use the same paper for the strips as the paper on which you are painting, as this can affect the finish.

Annotating colour matching strips

Once you have produced an accurate match, note down the colours you used and the proportions of each in the mix, as shown to the right. Doing this regularly will mean you start to build up a library of useful mixes that can help to give you a starting point for future mixes.

Creating form with paint

The time has come to begin to paint. This is looked at in more detail in the Six Stages of Painting chapter (pages 72–79), but the basic principles are important to understand. Firstly, paint is used to create the impression of shape and form in the flowers. This is where the lessons learned on tone (see pages 28–31) come in. However, rather than using continuous line shading, we apply the paint in many repeated layers. Practise painting the simple shapes here to get used to applying paint to create the impression of form.

Creating the form of ellipses with paint

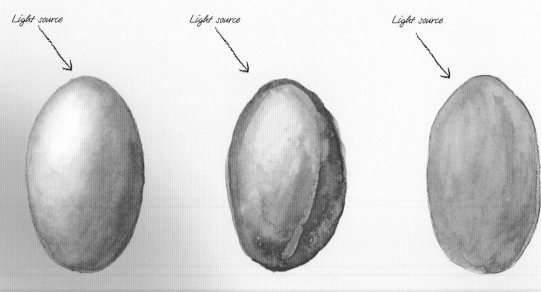

Light source

Light source

Light source

Correct

The paint here shows even gradation, leaving good highlights that face the light source, making the object appear smooth and three-dimensional.

Incorrect

Too much water has been used in some area, while in others the paint has been applied too thickly. This creates uneven edges and a blotchy, textured finish.

Incorrect

With no highlight following the first wash, the resulting object looks flat.

Creating the form of cones with paint

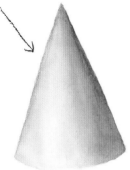

Light source

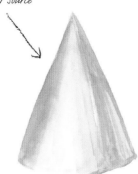

Light source

Correct

Aim for the even gradation and build up the tone seen here. Neatness at the edges helps to make the object appear three-dimensional.

Incorrect

The poor gradation of tone here has left visible lines. In addition, too much colour on the left-hand side makes the object appear flat and badly-lit.

Creating the form of columns with paint

Light source

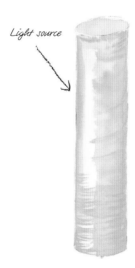

Light source

Correct

The clean gradation from light to dark, along with a light central highlight, suggests a smooth three-dimensional column. Note how the elliptical end has been shaded in the opposite direction to the outside – darker near the light source and lighter further away, making the shape appear like a hollow tube.

Incorrect

The pencil lines here are too dark – they remain visible in the finished piece. In addition, the use of horizontal lines to give the impression of form makes the object look textured. The paint in general has been applied in varied thicknesses, giving an uneven result.

Greens

Mixing greens can be a problem for the botanical artist, especially beginners. It is not often that colours straight from the tube or pan match the greens of nature, so you have to mix them in your palette. Practice is paramount to achieve a satisfactory colour.

It is obvious to mix blue and yellow to make a green; but which blue, and which yellow? How much of each?

Colour charts

The best way I have found of producing accurate, lifelike colours is to make colour charts using strips of the same watercolour paper as you use for the final painting. Start with two colours, cadmium yellow and French ultramarine, for example. Make a small square of the first colour (i.e. pure cadmium yellow), then add a little of the second colour while it is wet. Wash your brush, and then repeat with a little more of the second colour each time, making a number of squares with different proportions of the two colours.

Once you have made a range of mixes using the first colour as the base, try reversing the process: making squares of the second colour (French ultramarine) and adding increasing amounts of the first colour (cadmium yellow).

Try mixing different yellows with different blues for a huge range of green hues.

44

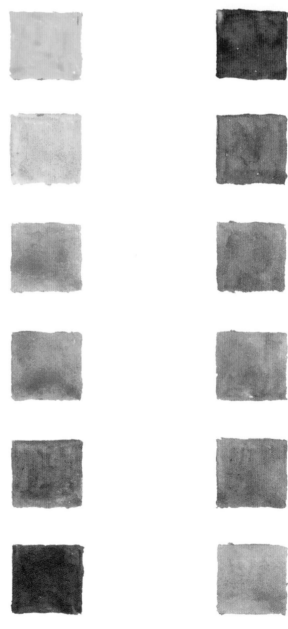

The topmost square of this column is pure cadmium yellow. Increasing amounts of French ultramarine have been added to the mix to make the squares lower down, resulting in a range of greens.

This example uses the same colours, but starts with the blue (French ultramarine) to which has been added increasing amounts of cadmium yellow. Again, a range of different greens are created.

Mixing complex greens

Permanent sap green is a versatile green in its own right, and it is also a great basis for a variety of other greens. From the bright acid greens of a chrysanthemum, to the dark blue-green of a rose stem, this green is a useful neutral starting point.

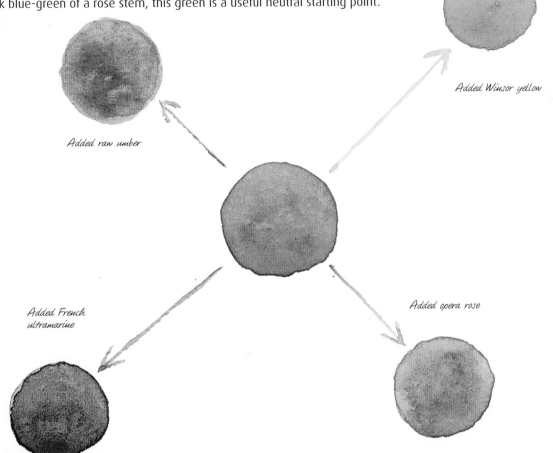

Added Winsor yellow

Added raw umber

Added French ultramarine

Added opera rose

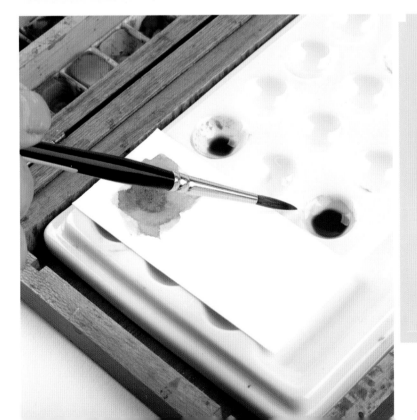

Tip

Try adding a little red to your green mixes. This warms and mutes the colour, which often helps to make a more natural colour for painting leaves.

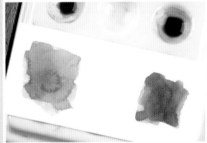

Compare the original mix of permanent sap green and French ultramarine (left) with the final mix, which has red added (right).

Greens to match the subject

The human eye is very sensitive to differences in greens, so it is very important to match the subject carefully. Even if the petals of your flower are perfect, the overall effect will look wrong if the supporting structures of the stem, leaves and so forth do not match the subject.

When mixing greens to suit your plant, use colour matching strips or a colour mixing chart and match as closely as you can. A useful tip is to actually put a small amount of paint on the plant's leaf or stem. If the paint blends in with the plant colour, your paint mix is correct. If not, the colour will stand out and you will know that you will need to modify the mix to suit. Always mix in daylight where possible to get the right results.

When the paint colour matches the leaf closely, you know that you have the correct hue.

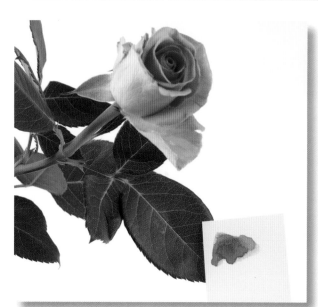

Close observation

Do not assume that a single green will suit: this rose leaf contains a variety of greens, from the yellow-green of the veins to the red-brown of the stem. However, the main colour is a mix of permanent sap green, French ultramarine and a hint of Sennelier red.

Complex greens

Some areas span a great deal of greens, like this chrysanthemum floret. Aim to mix the lightest tone you can see – the other tones will be produced with multiple layers.

The young and closed buds of this foxglove were given several washes of sap green and transparent yellow for a bright fresh green. A little more sap green was added to the same mix for the shadow areas.

The green for this fuchsia leaf was a mix of sap green and alizarin crimson, which produced a muted colour for this older leaf. Several washes were used until the correct tones were achieved.

These cool blue-green snowdrop leaves were given several washes of a manganese blue and sap green mix. A touch of alizarin crimson was added to the mix for the shadow areas.

Several washes of permanent sap green, with a little neutral tint added to the mix for the shadows, have been used here. This gives a strong green suitable for the stems of this calla lily.

This young bergenia leaf was given several washes of sap green and Winsor yellow for a rich, vibrant green. The shadow areas were darkened with the addition of a little alizarin crimson.

This is an older leaf from an aquilegia. Several washes of sap green and aureolin make a slightly desaturated green. A small amount of neutral tint was added to the mix for the shadow areas, and a final wash of transparent yellow stopped the colour from looking too muted.

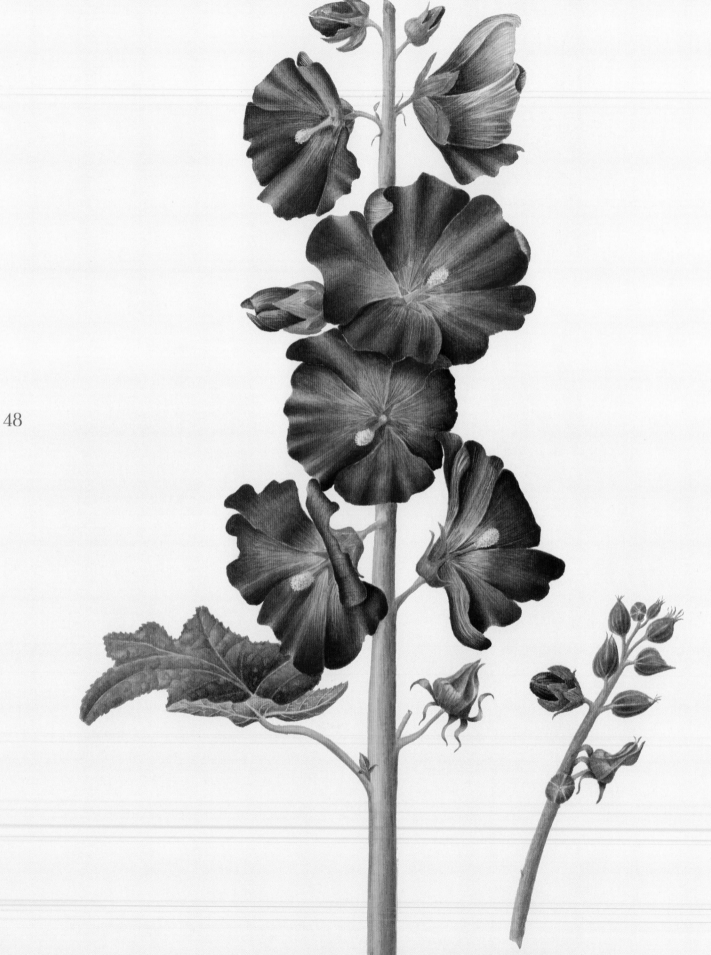

48

Developing your skills

This part of the book is your chance to practise the techniques explained earlier. To help make things more accessible, I have provided tracings for each of the three flowers, so that you can concentrate on the painting.

Using the tracings

Transferring the image to your paper could not be easier. Pull out the tracing you want to use from the front of the book. You will also be able to reuse the tracing several times.

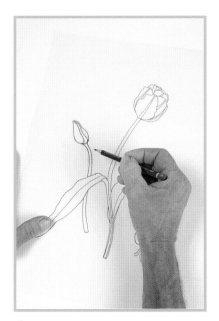

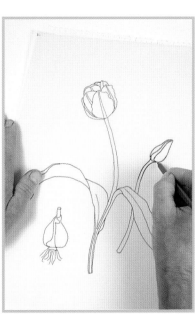

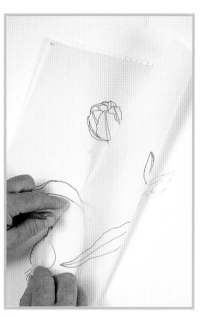

1 Place your tracing face-down on some scrap paper. Pressing quite heavily, go over the lines on the back using a 4B pencil.

2 Place the tracing face-up on top of your watercolour paper. Use a burnisher to go over the lines.

3 You can lift up the tracing from the bottom as you work, to see how the transfer of the image is going. Continue running the burnisher over the lines until the whole tracing has been transferred, then remove the tracing. You may wish to reinforce any very faint lines.

Opposite
Hollyhock
With all its creases and folds, the hollyhock Alcea rosea *is a complicated flower to paint. This makes it a great challenge, well-suited to the confident artist.*

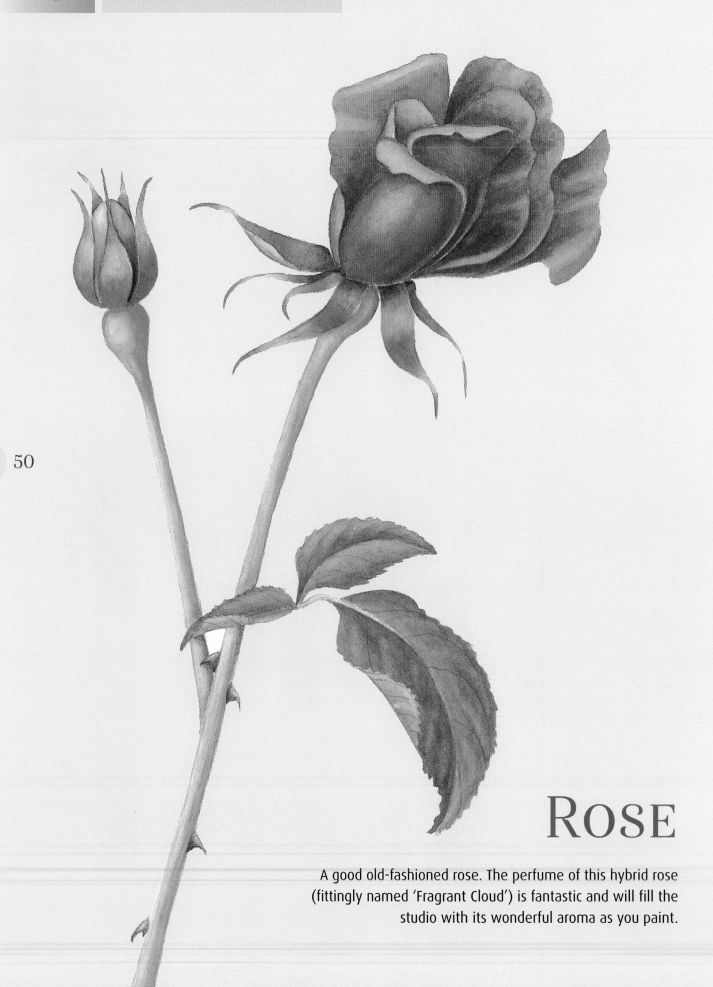

50

ROSE

A good old-fashioned rose. The perfume of this hybrid rose
(fittingly named 'Fragrant Cloud') is fantastic and will fill the
studio with its wonderful aroma as you paint.

You will need

- 300gsm (140lb) hot-pressed watercolour paper, 38 x 56cm (15 x 22in)
- Masking tape and board
- Pencil and putty eraser
- Colours: rose doré, sap green, Winsor yellow, French ultramarine, manganese blue, cadmium yellow, alizarin crimson, cadmium red, permanent magenta, neutral tint, transparent yellow
- Brushes: size 5 round, size 3 round, size 2 round, size 0000 round
- Kitchen paper

1 Transfer the image to the paper, then place it on the board and secure it in place with masking tape. Use a size 5 round to glaze the individual petals of the rose head with clean water. Apply a wash of fairly dilute rose doré to the base of the inside of one of the petals. Blend the colour out with clean water towards the tip to leave the highlights. Repeat on one of the non-adjacent petals.

2 Repeat on the insides of the remaining petals. When you are working, be careful to work on non-adjacent petals to avoid the areas of wet paint running into damp paint, which will cause backruns.

51

3 Glaze the bud with clean water. Add a gradated wash of rose doré in the same way as for the flowerhead.

4 Make a dilute well of sap green and Winsor yellow. Glaze the stems with clean water, then apply the mix to a section of the stem in a gradated wash, starting on the right-hand side and grading it out to the left with clean water. This will leave highlights as shown.

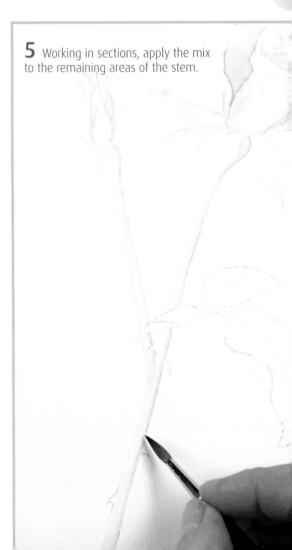

5 Working in sections, apply the mix to the remaining areas of the stem.

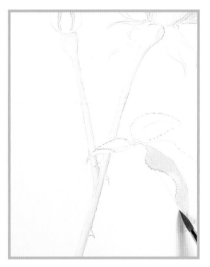

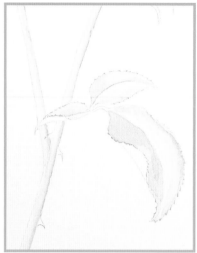

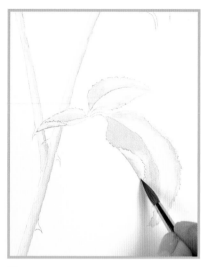

6 Glaze the leaves and sepals with clean water, then add a little French ultramarine to the green mix. Use this slightly darker mix to paint the area to the left of the midrib on the largest leaf. Paint into the serrations of the leaf.

7 Paint a gradated wash of the green mix to the right of the midrib, leaving a highlight as shown, then paint the other leaves in the same way.

8 Mix manganese blue with cadmium yellow and use this to lay in a gradated wash to the undersides of the leaves.

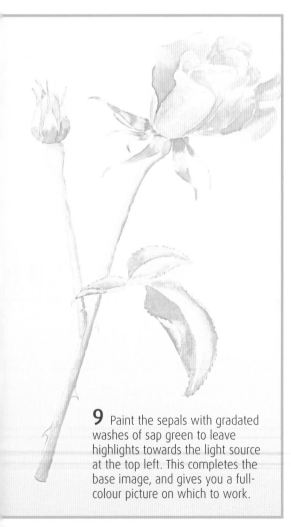

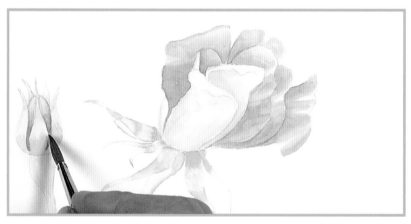

10 Make a mix of alizarin crimson and cadmium red, slightly stronger than the previous washes. Use this to paint the insides of the rose petals, paying particular attention to the light source to get the shading and highlighting correct. Use the same mix to lay in a second wash on the bud.

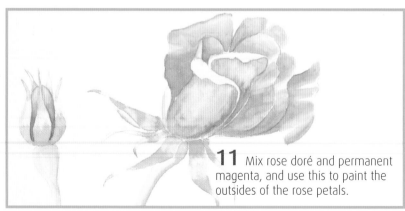

9 Paint the sepals with gradated washes of sap green to leave highlights towards the light source at the top left. This completes the base image, and gives you a full-colour picture on which to work.

11 Mix rose doré and permanent magenta, and use this to paint the outsides of the rose petals.

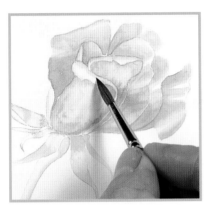

12 The curled-over lips of the rose petals are the insides, so use the alizarin crimson and cadmium red mix to paint them.

13 Begin to build up the stems with a second layer of sap green and Winsor yellow. Work with the same method, starting on the right-hand side and grading it out to the left with clean water. Work in sections, and once dry, apply a third wash in the same way.

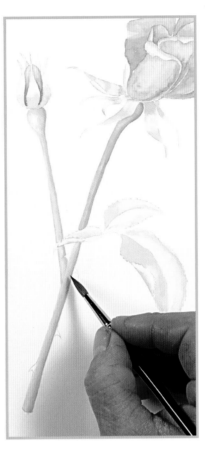

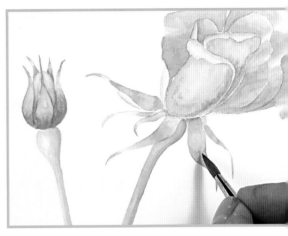

14 Using successive washes of the same mixes, build up the sepals with the same method. Strengthen the mix with each layer by adding more paint, and pay careful attention to the highlights and shading when grading out.

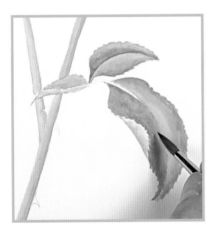

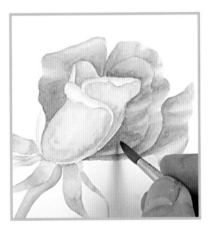

15 Strengthen the leaves with the mix of manganese blue and cadmium yellow for the undersides and the sap green, Winsor yellow and French ultramarine mix for the top sides.

16 Use the alizarin crimson and cadmium red mix to lay in a wash on the thorns. Apply the paint with a size 2 round.

17 Switch to the size 5 and strengthen the insides of the rose petals on the flowerhead with a rose doré and alizarin crimson mix. Strengthen the mix with more alizarin crimson and work it into the recesses.

Tip

When strengthening areas, be careful to leave the areas of highlight alone to maintain and enhance the three-dimensional effect.

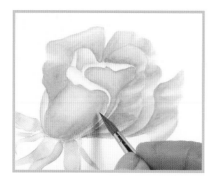

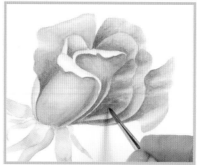

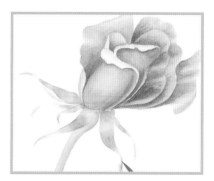

18 Strengthen the outside petals with a permanent magenta and alizarin crimson mix. Keep it moving to avoid hard lines on the petals: permanent magenta is a staining colour. Allow the flowerhead to dry.

19 Strengthen the flowerhead further by adding a mix of alizarin crimson and neutral tint to the shadow areas using the size 2 brush. Apply the mix to the recesses on both the insides and outsides of the petals.

20 Mix French ultramarine with sap green and add a touch of cadmium red. Still using the size 2 brush, use this mix to shade the leaves and sepals.

54

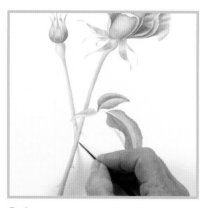

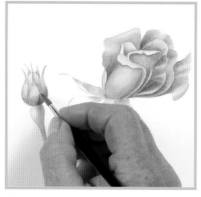

21 Repeat the shading process on the stems using a stronger mix of sap green and Winsor yellow.

22 Use the size 5 to wash a fairly strong mix of cadmium red and alizarin crimson over the petals of the flower, avoiding the highlights. Repeat on the bud.

23 Allow the paint to dry and repeat the wash over the flowerhead and bud. Again, be careful not to cover the highlights.

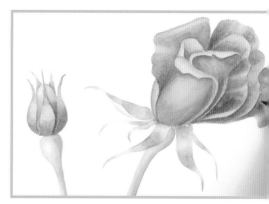

24 Using the size 2 brush, apply a mix of cadmium yellow and manganese blue to the undersides of the leaves and the leftmost sepal. Develop the sepals with sap green.

25 Using pure cadmium red and the size 5 brush, lay in another wash over the flowerhead and the bud; then another wash over the leaves using a mix of sap green and French ultramarine.

26 Mix Winsor yellow with a little sap green and use the size 2 to strengthen the petiole (the stalk that connects the leaf to the main stem). Use a dilute wash, and leave the bend on the stem lighter than the rest as a highlight. Develop the thorns with a mix of alizarin crimson and cadmium red.

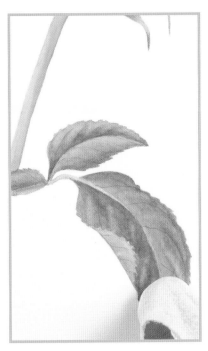

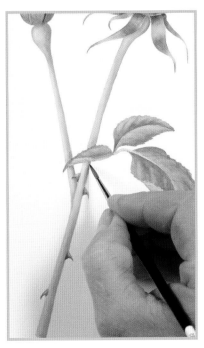

27 Mix sap green with neutral tint, and use the size 0000 to add veins to the leaves, to darken the shadow areas on the sepals beneath the petals and on the thorns.

28 Wet the raised areas on the top of the lower leaf using the size 3 brush and clean water. Dab clean, dry kitchen paper on to the area to lift out highlights.

29 Use the size 2 to apply neutral tint to areas that are overlapped or in shadow, such as the stem beneath the leaf. Blend out the tint with clean water.

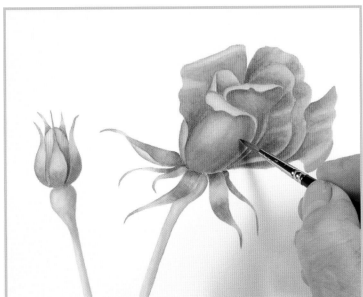

31 Use a very dilute wash of transparent yellow over the leaves, then leave to dry to finish. When completely dry, lightly remove any pencil marks with your putty eraser to finish.

30 Apply a very dilute wash of French ultramarine to the outer petals of the rose. Allow to dry, then apply a very dilute wash of cadmium red over the inner petals and the bud.

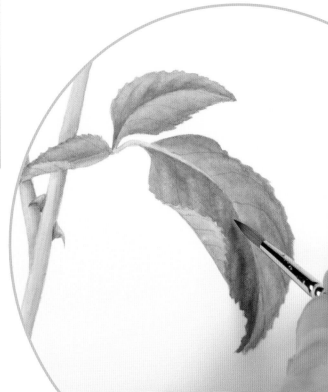

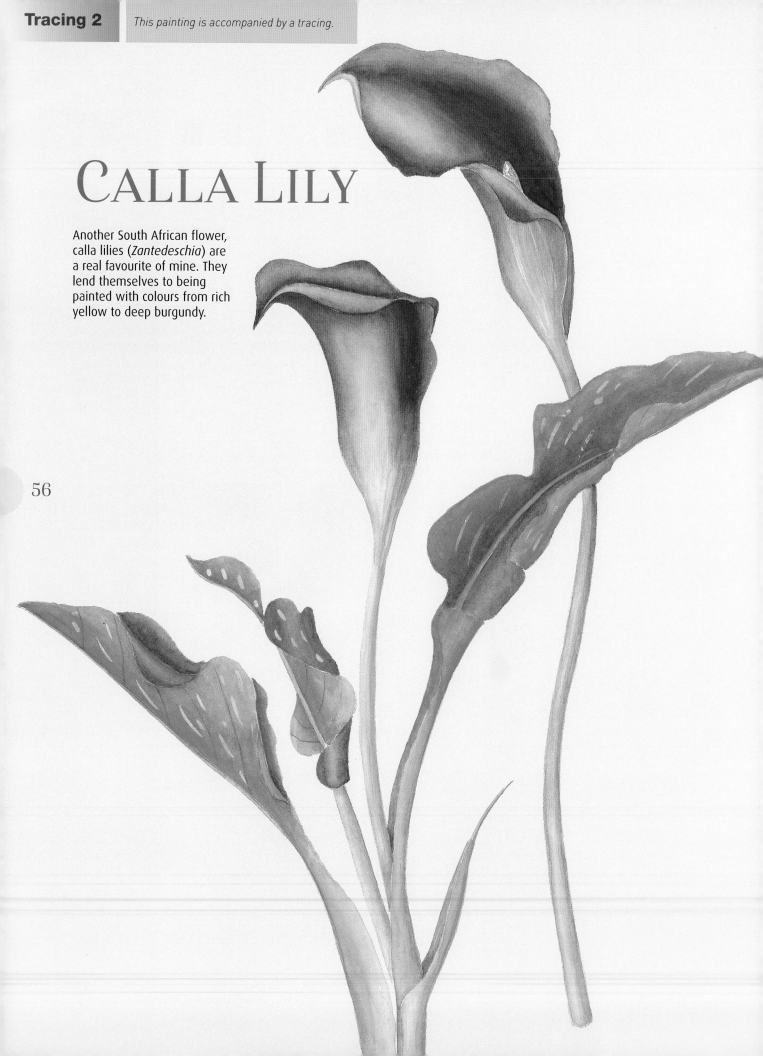

CALLA LILY

Another South African flower, calla lilies (*Zantedeschia*) are a real favourite of mine. They lend themselves to being painted with colours from rich yellow to deep burgundy.

56

You will need

300gsm (140lb) hot-pressed watercolour paper, 56 x 38cm (22 x 15in)

Masking tape and board

Pencil and putty eraser

Colours: manganese blue, transparent yellow, alizarin crimson, sap green, neutral tint, Payne's gray, yellow ochre

Brushes: size 5 round, size 3 round, size 1 round

Masking fluid and size 3 sable/synthetic brush

Liquid soap

Kitchen paper

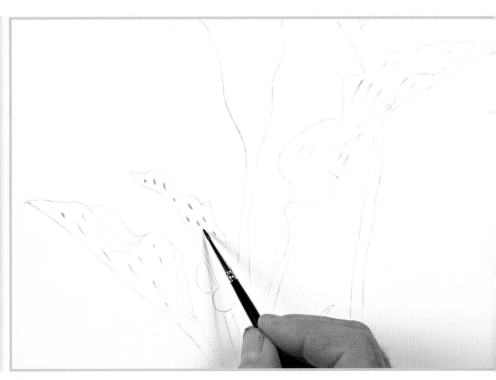

1 Transfer the image to the paper, then secure it to the board with masking tape. Use the size 3 sable/synthetic brush to apply masking fluid, as shown, to the leaves. Allow to dry.

57

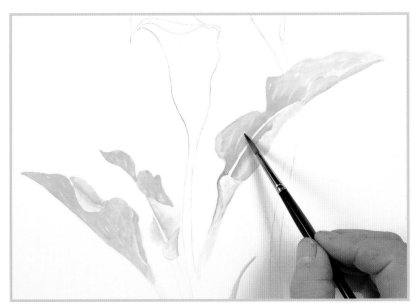

2 Use the size 5 round to wet the leaves with clean water. While wet, drop in a mix of manganese blue and transparent yellow, leaving the midribs clean and dry. Lay in more colour on the darker areas while the paint is wet, to begin to develop the modelling.

3 Glaze the paper with a little clean water, then apply alizarin crimson to the damp paper in the throat of the top flowerhead. Grade the colour out to the mouth of the flowerhead using clean water, being careful not to paint over the stigma.

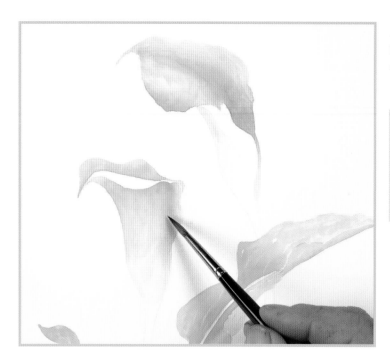

4 Repeat on the other flowerhead, including the outside of the flower as shown. Allow to dry.

Tip

If you are struggling to keep the stigmas clean, you can mask them with masking fluid.

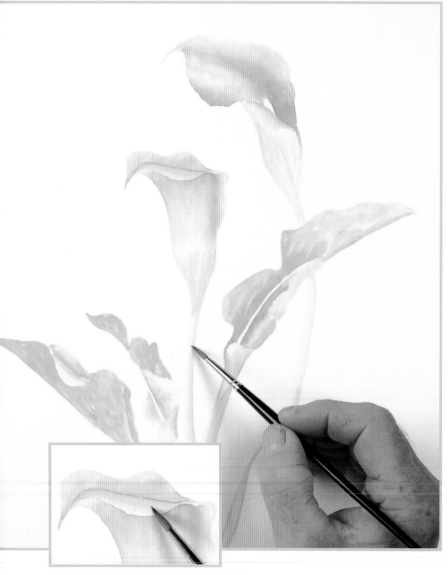

5 Use the same mix to paint the remaining areas of the petals where they curl over (see inset), then lay in an initial wash on the stems and lower parts of the flowers using the size 3 round and a mix of sap green and transparent yellow.

6 Prepare some alizarin crimson and use the size 5 round to develop the shading in the throat of the upper flower. Grade the colour away with clean water, avoiding the stigma.

7 Enrich the colour on the lower flower by glazing it in the same way with the same mix. Again, concentrate on the throat and below the curled-over petal.

8 Lay in a second wash of sap green over the right-hand leaf. Use the size 5 round with a slightly stronger mix of paint, and work outwards from the central part of the leaf. Use clean water to grade the paint out to the margins of the leaf, being careful to keep the midribs clean.

9 Paint the dark parts of the remaining leaves in the same way.

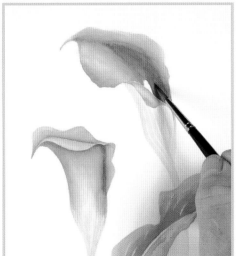

10 Mix alizarin crimson with a little neutral tint, and deepen the shading on the flowers with another glaze using the size 3 brush.

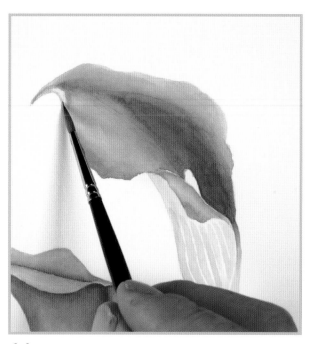

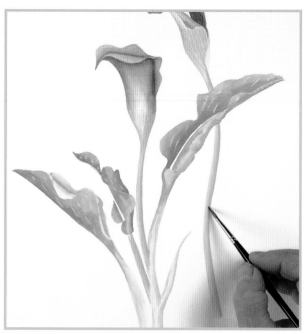

11 Using the sap green and transparent yellow mix with the size 3 brush, lay in a first wash on the curl of the tip of the upper flower.

12 Use the same mix to lay in another glaze over the stems and the lower parts of the flowers, merging the colours with the dry alizarin crimson. Lay in the glaze on the lower parts of the flower, to suggest the venation as shown.

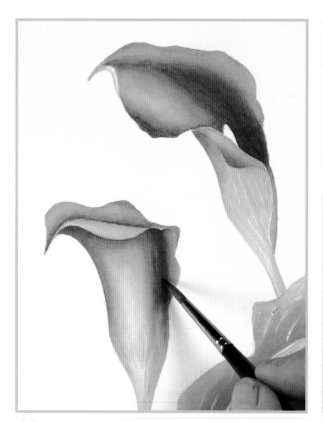

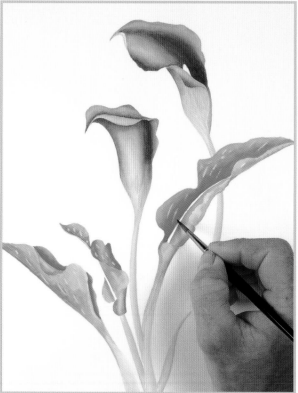

13 Change to the size 5 round brush and use the alizarin crimson and neutral tint mix to glaze the flowers once more, deepening the shading further and introducing it to the upper part of the green areas of the flowers.

14 Develop the upper parts of the leaves with a glaze of sap green. Pay careful attention that the highlights and shades remain in relation to the light source at the top left to ensure that the leaves look natural and correct.

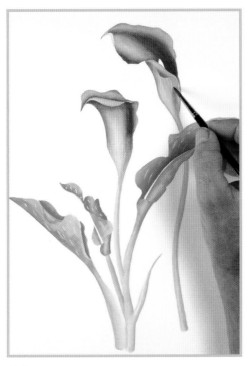

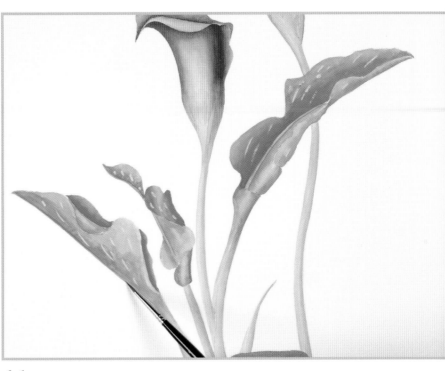

15 Lay the next wash onto the underside of the leaves, using a slightly thicker mix of sap green and transparent yellow. Wash the stems and lower parts of the flowers with the same mix.

16 Using a size 1 round with sap green, paint in the midribs on the three leaves.

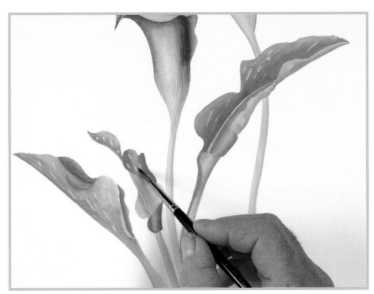

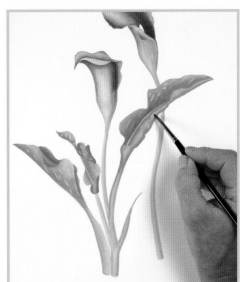

17 Make a darker mix of Payne's gray and sap green for the shadow areas on the tops of the leaves. Lay in the wash with the size 5 brush, and pay careful attention to the shapes of the leaves.

18 Lay in another wash of the sap green and transparent yellow to the stems, undersides of the leaves and the bottom of the flowerheads.

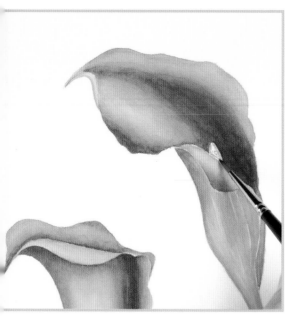

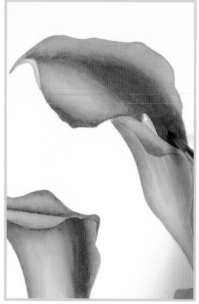

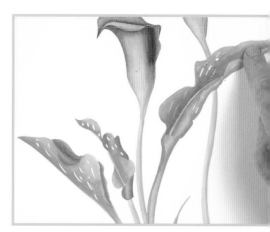

18 Concentrating on the topmost flowerhead, use the size 1 to apply the same green mix to the curl on the tip; then stipple yellow ochre on to the stigma, concentrating on the right-hand side and bottom to leave a highlight in the top left.

19 Switch to the size 5 and lay in a wash of alizarin crimson to the dark areas of the flowerhead, keeping the highlights clear.

20 Use a clean finger to rub away all of the masking fluid.

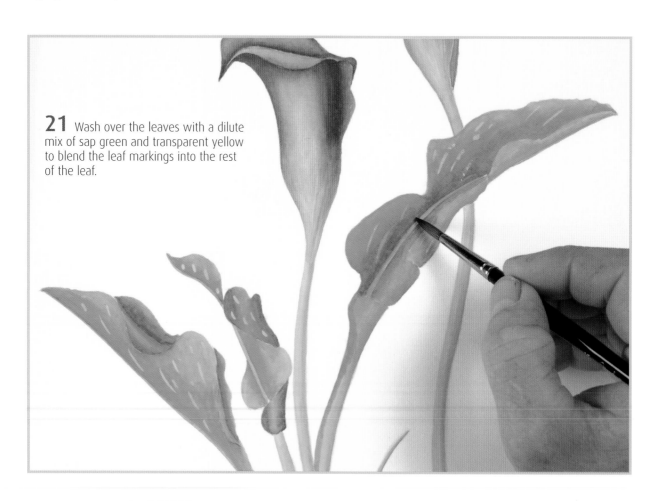

21 Wash over the leaves with a dilute mix of sap green and transparent yellow to blend the leaf markings into the rest of the leaf.

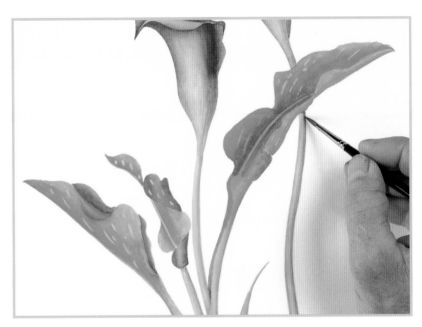

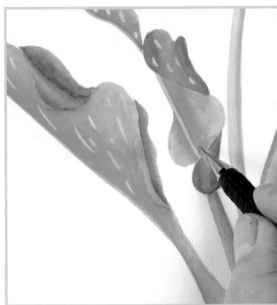

22 Switch to the size 3 round and dilute neutral tint. Apply this to the shadow areas on the stems and leaves.

23 Use a pencil to mark in light guidelines for the veins on the underside of the leaf.

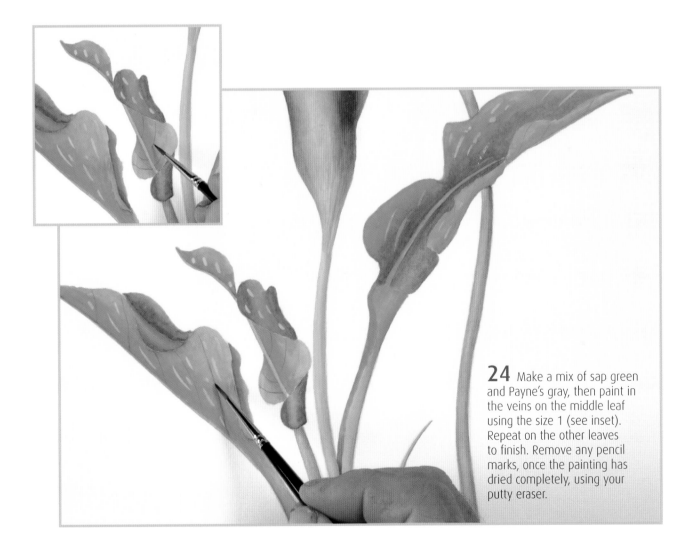

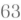

24 Make a mix of sap green and Payne's gray, then paint in the veins on the middle leaf using the size 1 (see inset). Repeat on the other leaves to finish. Remove any pencil marks, once the painting has dried completely, using your putty eraser.

64

IRIS

I was inspired by all the creases and folds
in the petals of this iris (*Germanica*), and
also by its rich colours as it stood proudly in
the herbaceous border.

You will need

300gsm (140lb) hot-pressed watercolour paper, 38 x 56cm (15 x 22in)

Masking tape and board

Pencil and putty eraser

Colours: alizarin crimson, cadmium yellow, cadmium red, neutral tint, transparent yellow, sap green, Payne's gray, raw umber, cadmium orange

Brushes: size 5 round, size 3 round, size 2 round, size 1 round

Kitchen paper

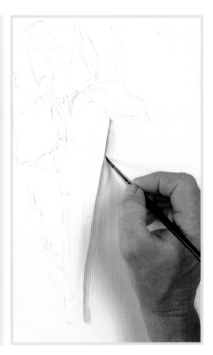

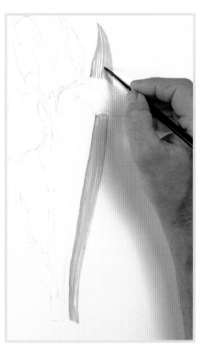

1 Transfer the image to paper, then secure it to the board with masking tape. Glaze the leaf with clean water, using the size 5 round, then apply sap green to the right of the midrib on the lower part of the leaf. Gradate it out to the right with clean water.

2 Draw long narrow vertical lines down the leaf with confident strokes of the brush to suggest striation, then paint the upper part of the leaf in the same way.

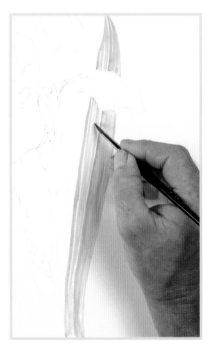

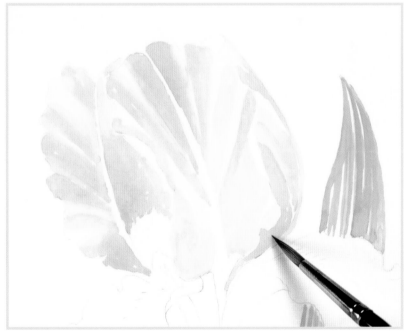

3 Repeat on the left-hand side of the lower part of the leaf.

4 Prepare very dilute cadmium yellow and paint the standards (the upright petals) with the size 5 round brush. Leave clean paper for highlights as shown.

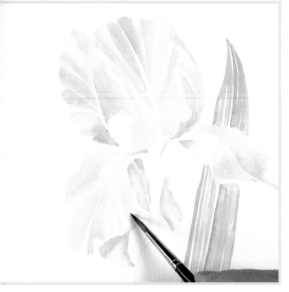

5 Paint the falls (the outer sepals) in the same way, being careful not to paint the beards.

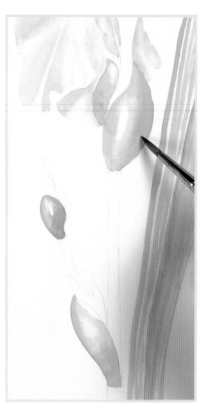

6 Prepare a well of sap green and paint the four opening buds with clean water. Paint the wet buds with a graded wash of sap green, leaving clean paper as a highlight in the top left of centre as shown.

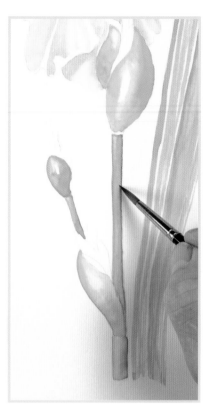

7 Mix sap green and Payne's gray. Glaze the stems with clean water, then lay in a wash of the mix using the size 5 round, keeping the centre of the stem lighter than the right-hand side.

8 Paint the undersides of the falls with a mix of sap green and transparent yellow, again leaving the highlights pointing towards the light source at the upper left.

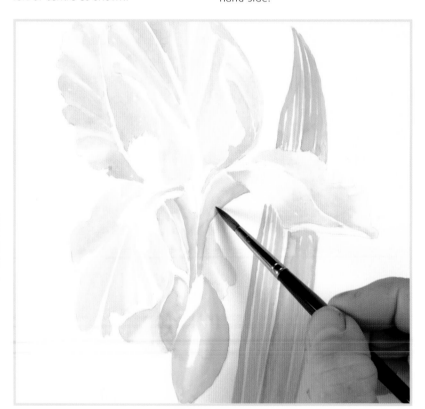

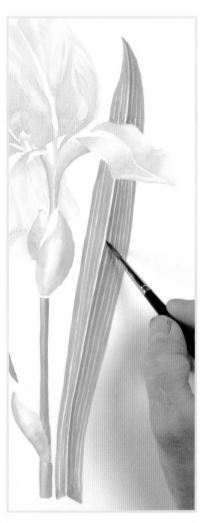

9 Paint the stigma with dilute cadmium orange and the size 3 brush, making the lower part darker than the upper. Leave the midrib white.

10 Use the same colour to lay in a wash on the inner part of the upper side of the falls, and also the lower parts of the standards. Be careful to leave the highlights clean while grading the colours out.

11 Use the size 5 round to paint vertical lines of sap green down the leaf to reinforce the striation. Make the lines near the midrib darker than those further away.

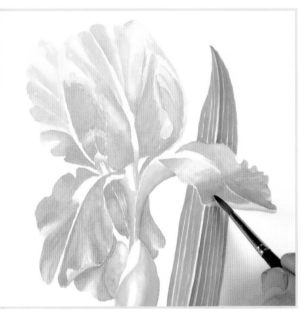

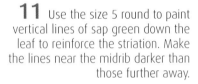

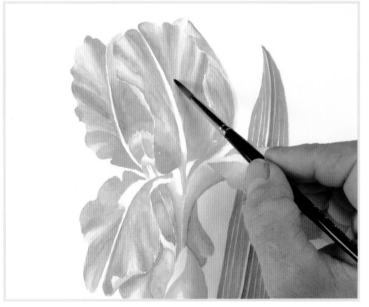

12 Mix alizarin crimson with raw umber and lay in a thin wash on the lower part of the falls, being careful to avoid the areas of highlight. Grade the paint to develop mid-tones as shown.

13 Paint the standards in the same way. Work in small sections, applying tiny amounts of paint and grading them out. The paint will dry quickly, and further paint can then be added to the same area without causing backruns.

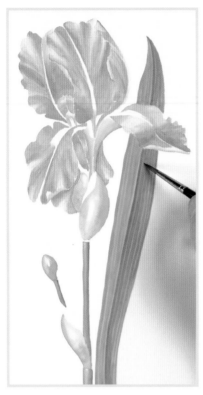

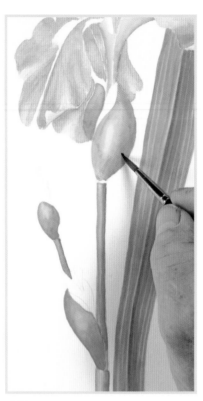

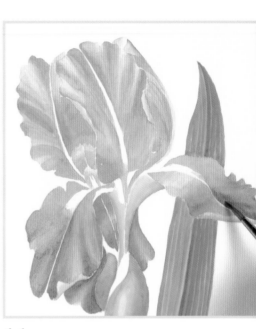

14 Still using the size 5 brush, wash a mix of sap green with a touch of transparent yellow over the leaf to bind the colours together.

15 Wash over the buds with dilute sap green, reinforcing the shaded areas and working round the highlight when grading the paint out.

16 Lay in another wash of raw umber and alizarin crimson over the same areas as before on the falls. This reinforces the colour.

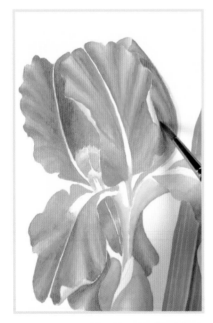

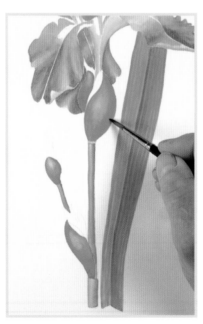

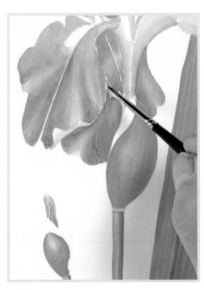

17 Reinforce the colour on the standards in the same way, grading out small areas as before.

18 Lay in a wash of sap green and transparent yellow on the leaf, then reinforce the buds with a pure sap green wash.

19 Switch to the size 1 round to apply a mix of alizarin crimson and raw umber to the emerging flowerheads – one is on the second bud from the bottom, while the other is near the falls of the main flowerhead.

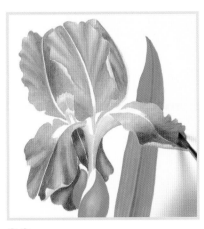

20 Add neutral tint to the alizarin crimson and raw umber mix and shade the falls further by applying the mix in the recesses of the same areas as before. Develop the creases in the recesses.

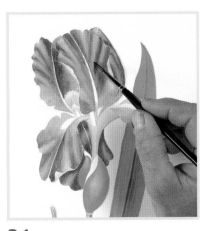

21 Enrich the standards with the same mix and technique. The curves and textures you establish here help to lead the eye and create the illusion of three-dimensionality.

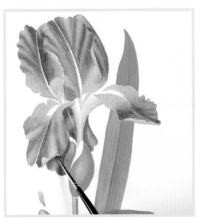

22 Mix cadmium orange with cadmium red and switch to the size 3 brush. Use this on the stigmas and the underside of the petals where they curl up or round.

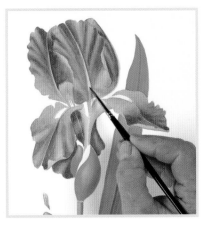

23 Paint all the midribs with a mix of sap green and transparent yellow, applying the colour with the size 5 brush.

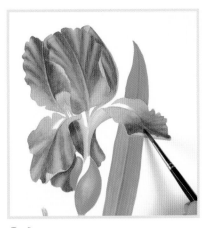

24 Wash the petals with fairly dilute alizarin crimson. Avoid the areas of highlights but include the midribs.

25 Lay a wash of sap green and Payne's gray on to the leaf's midrib, then grade it out to the right-hand margin of the leaf. Next, draw a line down the left-hand margin and grade it out to the midrib.

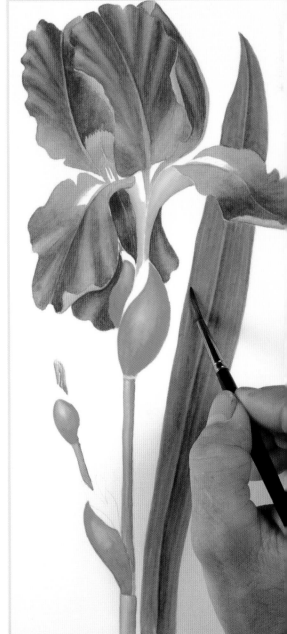

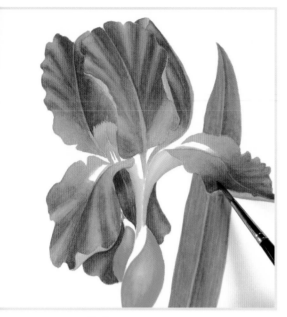

26 Wash the petals once more with dilute alizarin crimson.

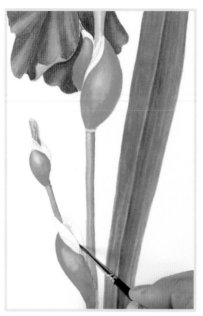

27 Use neutral tint, diluted so much that it appears a botanical grey, with a size 1 brush to paint in the membrane details on the buds.

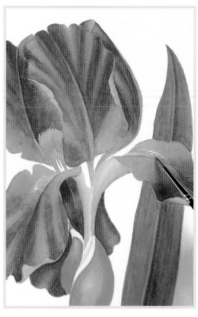

28 Still using the size 1, begin to suggest the beard with fine strokes of cadmium yellow.

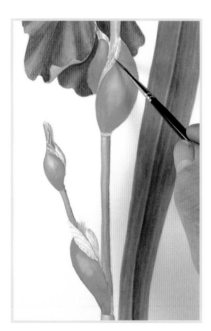

29 Add a thin wash of raw umber over the bud membranes to add detail, making tiny strokes to suggest texture. Putting the fine lines closer together at the bottom right creates shading.

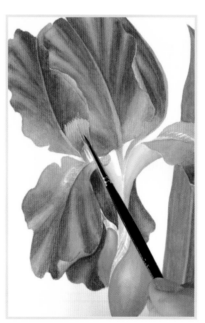

30 Tone down the orange curls of the petals using the botanical grey neutral tint. Use the same mix to add details to the stigma.

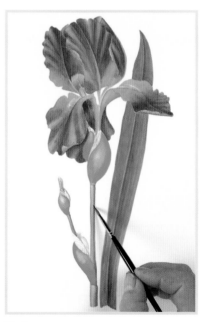

31 Lay in a final wash on the stem above the largest bud with the size 3 and a mix of sap green and transparent yellow. Add a little neutral tint to the mix and paint a subtle shadow on the right of the main stem below the largest bud.

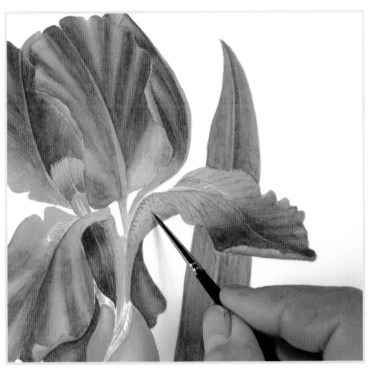

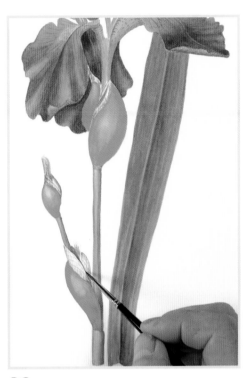

32 Applying the paint with the size 2, add the veins to the falls using dashes and dots of an alizarin crimson and neutral tint mix. This suggests the characteristic venation.

33 Use a stronger mix of neutral tint to detail the bud membranes.

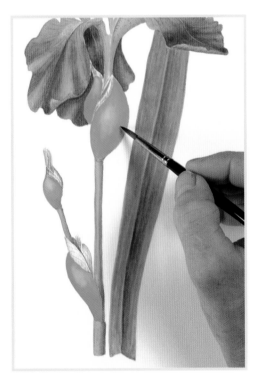

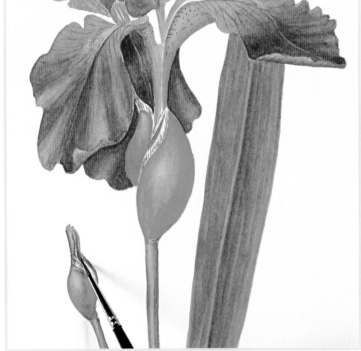

34 Lay in a wash of transparent yellow to the stem and buds using a size 5 brush.

35 Detail the flowers emerging from the buds with an alizarin crimson and neutral tint mix and size 1 brush, grading the colour out to add form. Use cadmium orange over this for the final highlights. Rub away any pencil marks with the putty eraser once the painting is completely dry.

Stage 2 – Tonal washes

When the first layers are completely dry, you can begin to use the stronger mixes from your palette (wells 3 and 4) to develop the form and give a three-dimensional appearance to the flower. You achieve this by grading the colour into the highlights using clean water. You will need to work quickly to avoid hard edges in your work, which are difficult to grade away.

By the end of this stage, the colour of the painting should match your sketch notes – and more importantly, the original subject.

1 Wet the area once again using clean water.

2 Use a single stroke to apply a wash of the stronger mix from well 3 into the shadow areas, grade the colour away towards the highlights and allow to dry.

3 Once dry, repeat the process using the strongest colour, from well 4.

4 Continue repeating the process with the third and fourth wells until the colour of the area matches the original flower.

Note

Because these wells have stronger mixes than those used for the first wash stage, you will need slightly less paint on your brush; the colour still needs to grade away to nothing.

74

Order of work

When you start to paint the tonal washes stage, you should organise an order of preference, so that the paint on the areas on which you are working does not run into nearby areas that are still wet – this can create backruns. A good order of work will ensure that you can keep the edges of your work crisp.

Another thing to bear in mind is that you are working from life, and the flower can change quickly. In order to avoid difficulty later, paint the parts that change the fastest first, then move on to the more stable parts: paint buds first, then the open flowers, then the leaves, then the stems. If a root system is to be included, paint this last, as the roots will not change very much.

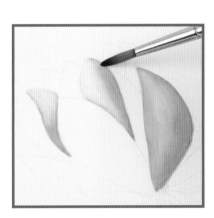

1 When painting flower petals, for example, it is best not to move on to a petal immediately next to the last one worked. Instead, work on one further away from the wet area.

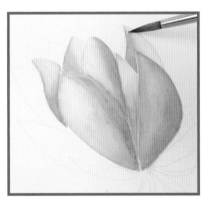

2 Return to the skipped petals or other areas later, once the first areas are dry.

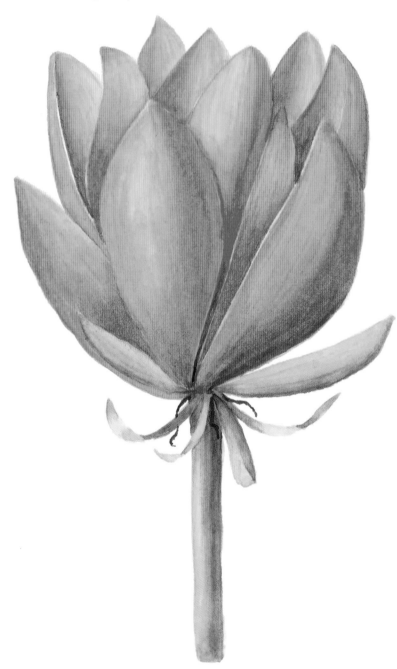

Once the petals were all completed, the stem and sepals were worked in turn. Again, non-adjacent areas were painted, and blank areas were filled in once the first group was dry.

Stage 3 – Crossovers

This stage puts the components of the flower into the correct positions, by painting small areas of shadow where areas cross and overlap. This knocks back the parts that are further away, making them appear more distant, rather than physically connected to parts of the plant in the foreground. This can be particularly useful for clarity if the parts to be knocked back are the same colour as those remaining in the foreground.

To add the crossover shading, a darker shade of the same colour can be used, or neutral tint in various strengths: the darkest shade for the greatest distance, working through midtones to the lightest tint for the areas to be knocked back the smallest distance from the foreground.

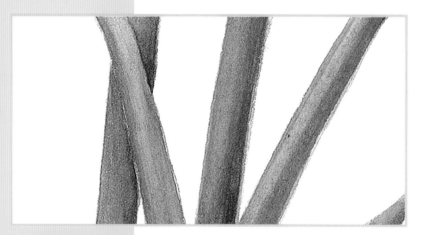

These lily stems cross over each other, so neutral tint has been glazed over the rearmost stem where the foreground stem overlays it. Notice that the effect is subtle: the original colours laid down in stage 1 are tinted, not covered.

It is not just stems that overlap one another, as this peavine leaf demonstrates. The process is approached in exactly the same way, but note that you must use either neutral tint (which works well with almost all colours) or a darker shade of the colour used on the background part (in this case, the stem), if it is different from the overlying part.

This cyclamen shows an excellent example of using the darkest shade next to the lightest tint, to suggest a large distance between the two stems.

Stage 4 – Harmonisation

The harmonisation stage can be daunting, especially to the beginner. However, it brings together the colours on the painting and adds a great deal to the realism of the finished painting. As a result, it is well worth a little extra effort.

Light interacts with the colours of the flower. For example, a blue flowerhead juxtaposed with a green leaf will lend a blue hue to the leaf, and in return will have a little green light reflected on to it. This effect is most marked where the light in the painting is strongest.

To represent the effect, a diluted wash of the reflected colour is applied evenly on to the affected part and gradated away. Allow the wash to dry, then judge whether a second – or even third – layer should be applied.

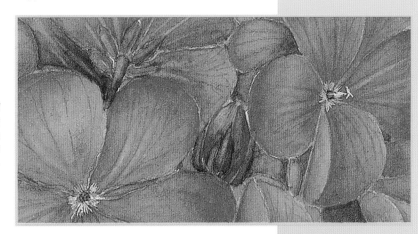

This geranium bud provides a good example of the effect, as the bright red of the surrounding petals is reflected on to the sepals of the bud, and vice versa.

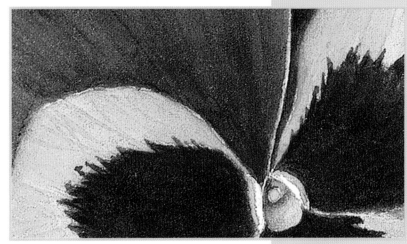

The effect is subtle, but noticeable, in the harmonisation between the two petals on this flower.

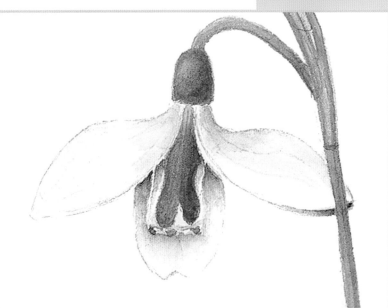

You should make the harmonisation very subtle when dealing with white petals, as the colour is very sensitive to change.

Stage 5 – Details

At this stage, the finer details such as barbs, hairs, stigmas and stamens are added along with surface details such as venation, speckles and spots. When applying these details, attention must be paid to their position: hairs that are in shadow should be darker in tone than those in direct light, for example. If this procedure is not adhered to, the painting will take on an unwanted stylised appearance.

 Make sure that these details are applied delicately, and remember that even the smallest parts still have a distinct form, so do not paint them with solid blocks of colour.

Tip
White gouache can be used for delicate highlights on even the tiniest parts of a flower.

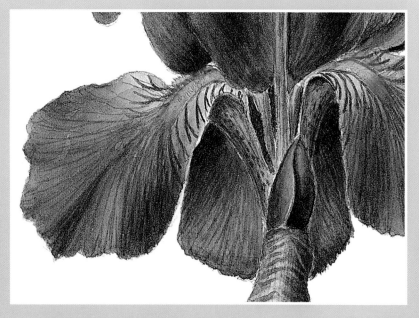

The venation on the petals in this example shows how the tone of paint used varies with the position of the area of detail in relation to the light source.

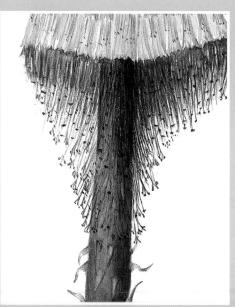

The dozens of tiny parts below the flower spike of this red hot poker require careful brushwork to achieve a realistic finished painting.

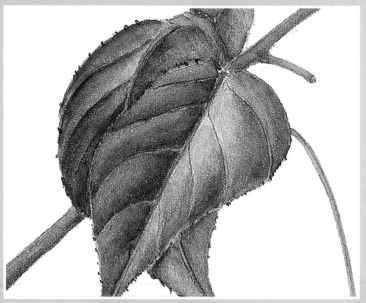

Leaves and stems require just as much attention to detail, as this example demonstrates.

Stage 6 – Discretionary washes

Unless you are extremely careful in how you apply the details in stage 5, some detail lines will look too dark and heavy. If this occurs, you can apply a very thin wash of the appropriate colour to the area. This helps to blend the different tones together without destroying the detail work or changing the basic colour of the area too radically.

Some areas benefit from a thin wash of a transparent colour. As an example, a glaze of transparent yellow on a green leaf will give it a lustre. As the name of the stage suggests, these washes are purely optional – if you feel that the painting is finished, then do not change anything.

Tip

Discretionary washes are just that: discretionary. If your work is correct at the end of stage 5, then there is no need to alter any of the elements.

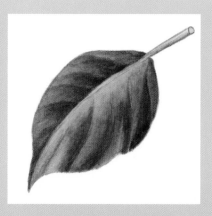

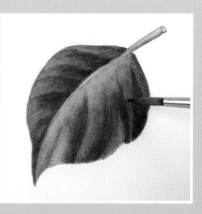

1 Identify whether you consider the area complete. This leaf is essentially finished, with all the tonal washes and detailing complete. However, it may benefit from a subtle wash to help enrich the colours.

2 Lay in a very thin wash of a colour from well 1 (in this case, transparent yellow) over the whole area and allow to dry.

79

The addition of a subtle transparent yellow wash enriches the colours, helps to merge and blend the different areas and gives the impression of sunlight, adding to the realism of the piece.

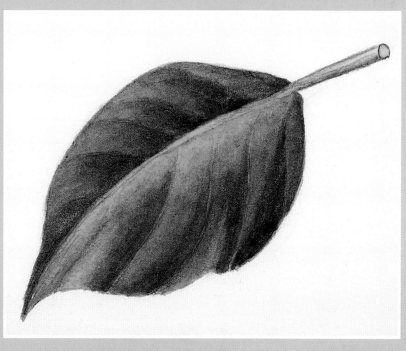

Using worksheets

Creating a worksheet

It is essential to produce specific practise pieces before you start to work on the final painting. Creating a 'worksheet' that lets you investigate, explore and understand each part of the flower you intend to paint will build up invaluable experience and understanding of the specifics of the subject.

Earlier in the book we looked at selecting and dissecting a flower, before carefully observing and drawing out each part. This is an extension of that process, and one that makes the link between those early preparatory stages and the final painting.

Referring to your dissection and preparatory drawings, draw out individual parts of the composition: the petals, seedhead, leaves, bud, stamens and stems as accurately as possible, then transfer them to your worksheet. Use a piece of paper identical to that which you will produce the final painting upon for your worksheet. In this example, I am using hot-pressed 300gsm (140lb) paper.

Once transferred, use the six stages of painting to practise painting the individual parts separately, as shown on this page. Make notes on the colour mixes, number of layers, and any unusual techniques or notable points that you need as an aid to your memory.

80

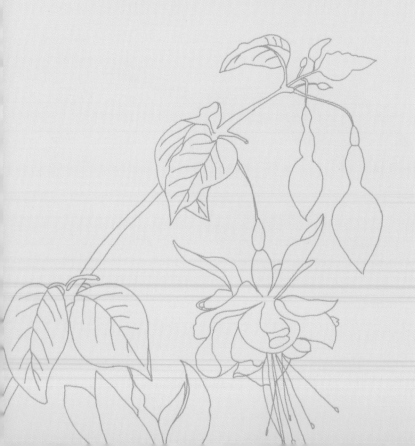

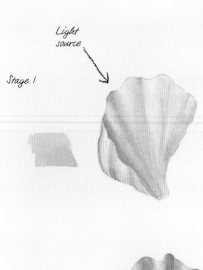

Light source

Stage 1

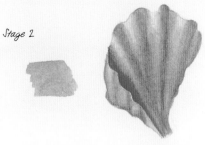

Stage 2

Final stage

Leave a thin line to show thickness of petal

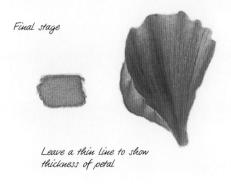

Petals
Cadmium red and Winsor lemon

Same mix with more yellow added

Shadows
Add alizarin crimson

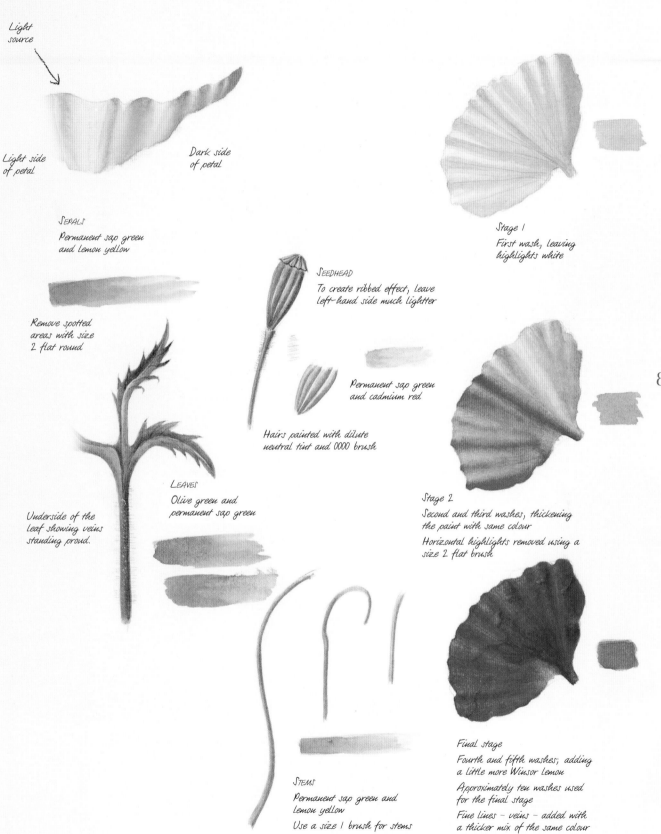

Light
source

Light side
of petal

Dark side
of petal

Stage 1
First wash, leaving
highlights white

SEPALS
Permanent sap green
and lemon yellow

Remove spotted
areas with size
2 flat round

SEEDHEAD
To create ribbed effect, leave
left-hand side much lighter

Permanent sap green
and cadmium red

Hairs painted with dilute
neutral tint and 0000 brush

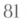

Stage 2
Second and third washes, thickening
the paint with same colour
Horizontal highlights removed using a
size 2 flat brush

LEAVES
Olive green and
permanent sap green

Underside of the
leaf showing veins
standing proud.

STEMS
Permanent sap green and
lemon yellow
Use a size 1 brush for stems

Final stage
Fourth and fifth washes; adding
a little more Winsor lemon

Approximately ten washes used
for the final stage

Fine lines – veins – added with
a thicker mix of the same colour

81

Using the worksheet

With your confidence built through tackling each element one at a time, you can begin to create your painting. Keep your worksheet close at hand as you work, but don't copy from it. The flower itself must remain the main source of reference, or you risk introducing inconsistences and errors.

Nevertheless, the worksheet is useful to help guide you and act as a reassuring anchor point. The notes you made will help you when you reach those nagging questions – is this part complete? Is the mix here made in the same way as earlier? – and help to ensure that you can concentrate on accuracy and enjoying yourself as you paint.

82

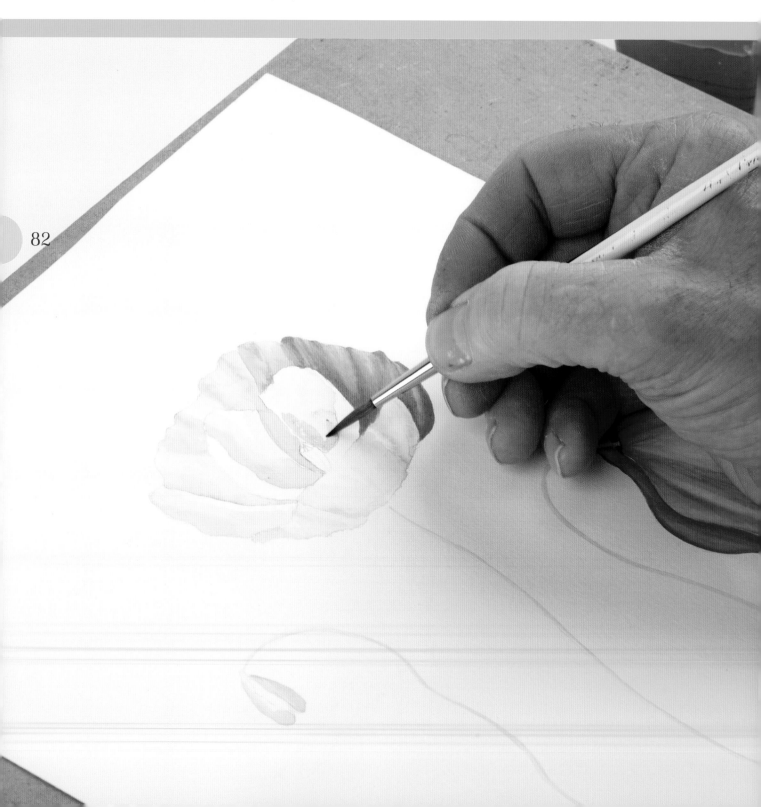

Early stages of the poppy painting

First thin washes

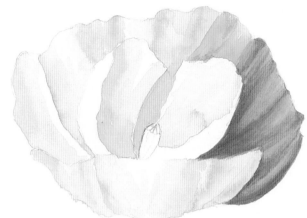

Depth of colour after four washes – note the lower part of the petals is much darker

First wash on opening bud

First, second and third washes, grading and painting darker tones to show the inner and outer petals

When tackling the painting itself, my notes were useful to help remind me which brushes I used for each part – here I am using a size 3 sable brush to apply the washes to the focal flowerhead.

My notes remind me to build up non-adjacent petals so I can keep working while avoiding the risk of areas of wet paint bleeding into one another.

Later stages of the poppy painting

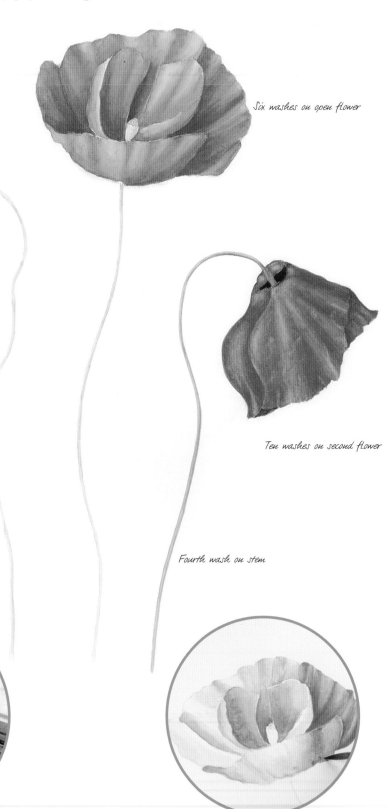

Six washes on open flower

Fourth wash on opening bud

Ten washes on second flower

Fourth wash on stem

Keep your mixes and water clean, and refer both to the worksheet and the flower for your reference.

Botanical painting takes patience. Do not rush the layering; the tone and vibrancy of the colour rely on many individual layers.

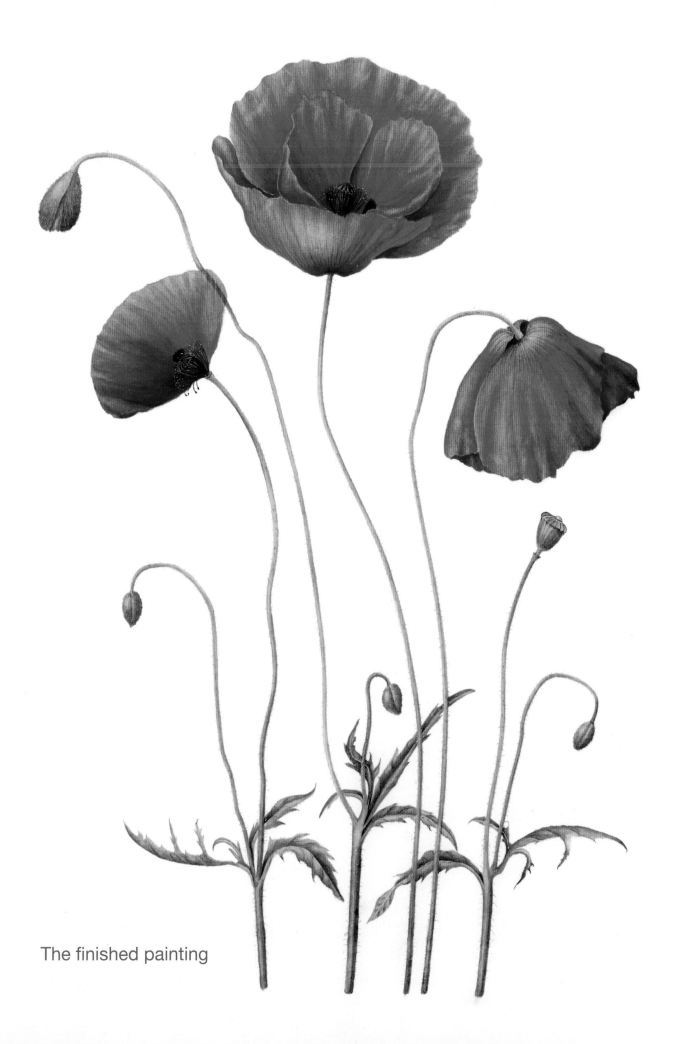

The finished painting

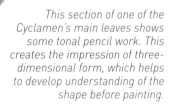

Cyclamen

Cyclamen concerto, known as 'Violet Improver', is originally from Turkey. It was first recorded on woodcuts dated from 1460, and arrived in Western Europe in the 1750s. A tuberous plant with shuttlecock-shaped flowerheads and various leaf patterns, it has many hardy varieties as well as the many pink-red shades of the familiar indoor specimens.

86

This section of one of the Cyclamen's main leaves shows some tonal pencil work. This creates the impression of three-dimensional form, which helps to develop understanding of the shape before painting.

The twisted buds are a delight to paint. Each ridge is shaded from right to left to create form.

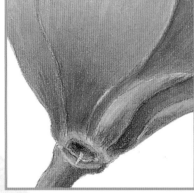

At the base of the petals, a small round lip is visible. This must show on your painting.

Note the different shades of colour on the underside of the leaves. The veins cast shadows which help to make them stand proud.

Worksheet

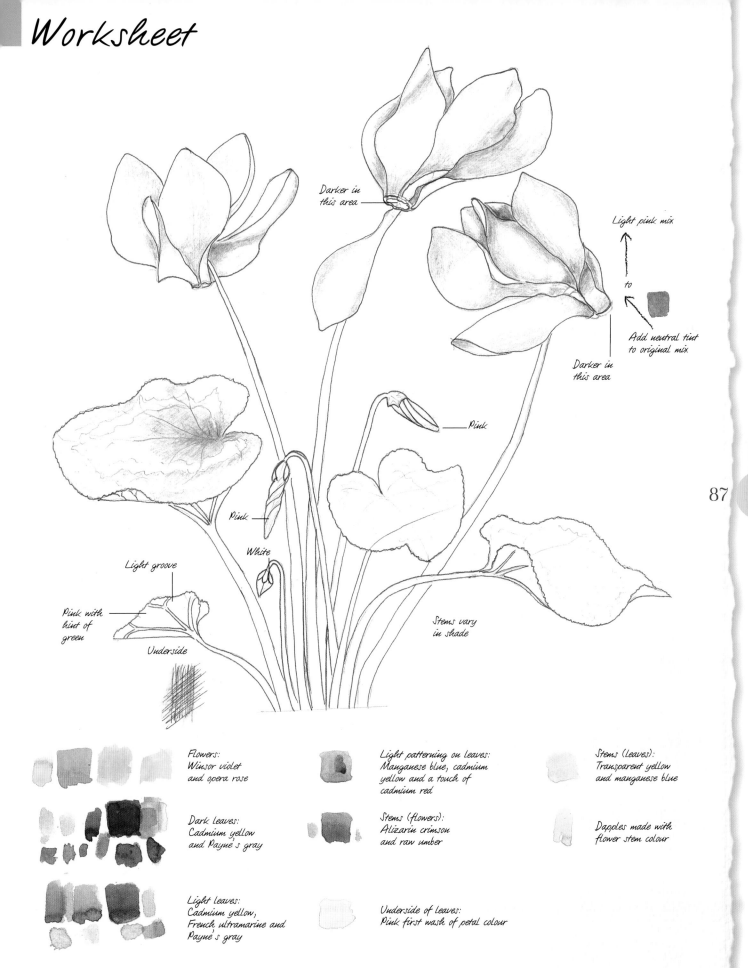

Darker in
this area

Light pink mix

to

Add neutral tint
to original mix

Darker in
this area

Pink

Pink

White

Light groove

Pink with
hint of
green

Underside

Stems vary
in shade

Flowers:
Winsor violet
and opera rose

Dark leaves:
Cadmium yellow
and Payne's gray

Light leaves:
Cadmium yellow,
French ultramarine and
Payne's gray

Light patterning on leaves:
Manganese blue, cadmium
yellow and a touch of
cadmium red

Stems (flowers):
Alizarin crimson
and raw umber

Underside of leaves:
Pink first wash of petal colour

Stems (leaves):
Transparent yellow
and manganese blue

Dapples made with
flower stem colour

Painting the cyclamen

Transfer your drawing to hot-pressed watercolour paper and prepare the wells of colour.

First wash

1 Firstly, glaze over all of the petals with clean water using a size 3 brush and leave them to dry. Once dry, apply the first diluted wash of opera rose and Winsor violet to the petals, leaving the highlights unpainted but grading the wash into them, taking note of the highlights from the tonal drawing.

2 Glaze the leaves with clean water and allow them to dry. The older leaves are darker, so apply a dilute wash of cadmium yellow and Payne's gray leaving the lighter pattern areas unpainted. Add more cadmium yellow and a little French ultramarine to the mix and apply a dilute wash to the younger leaves.

3 Glaze all of the stems with clean water using a size 3 brush and leave to dry, before applying a dilute mix of transparent yellow and manganese blue to the leaf stems. Apply a mix of alizarin crimson and raw umber to the flower stems.

4 Paint the undersides of the leaves with a dilute wash of the petal colour.

5 Glaze the two larger buds with water, then apply the flower mix, leaving the highlights clean. Paint the lighter patterns on the leaves with a dilute wash of cadmium yellow, manganese blue and a little cadmium red.

Tonal washes

1 Using the same colours and brush sizes, but with slightly stronger mixes, apply second washes, replicating what you did earlier by leaving the highlights unpainted but gradated into. Repeat this process until you have a three-dimensional image.

Crossovers

1 Using neutral tint added to the flower colour mix, paint into the shadow areas, making them darker on the petal at the base and lighter towards the point of each flower.

2 Apply shadows behind the crossing stems by adding neutral tint to the original mix of the stems.

Harmonisation

1 Using a size 3 brush and the original dilute wash of pink, wash over the leaf closest to the flower.

2 With a dilute green wash, paint over the lower part of the flower petals.

Details

1 Leave the small bud as white paper, but put in shadows to create form with neutral tint.

2 Give the sepals a wash of manganese blue, cadmium yellow and a touch of cadmium red, repeating the layers until the depth of colour is correct.

3 Paint the faint lines on the petals with a size 1 brush and a slightly darker mix of the petal colour with French ultramarine added.

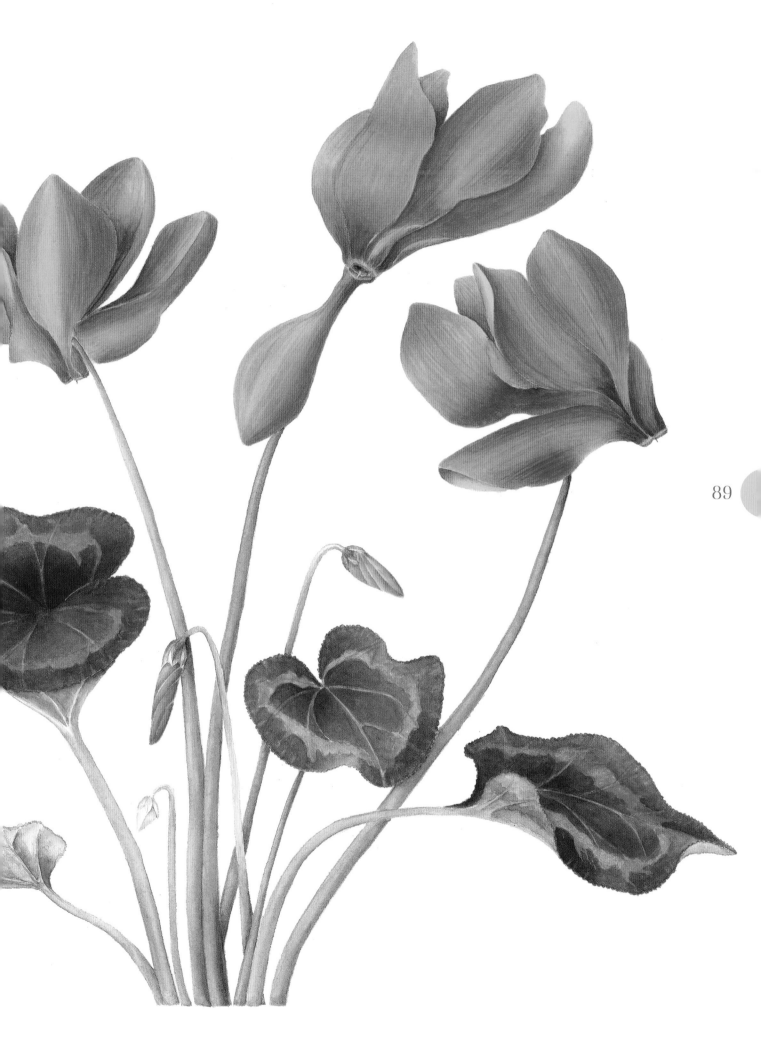

Purple Coneflower

Echinacea purpurea is native to North America and is known for its medicinal properties. It is a much-loved herbaceous plant and is available in various shades.

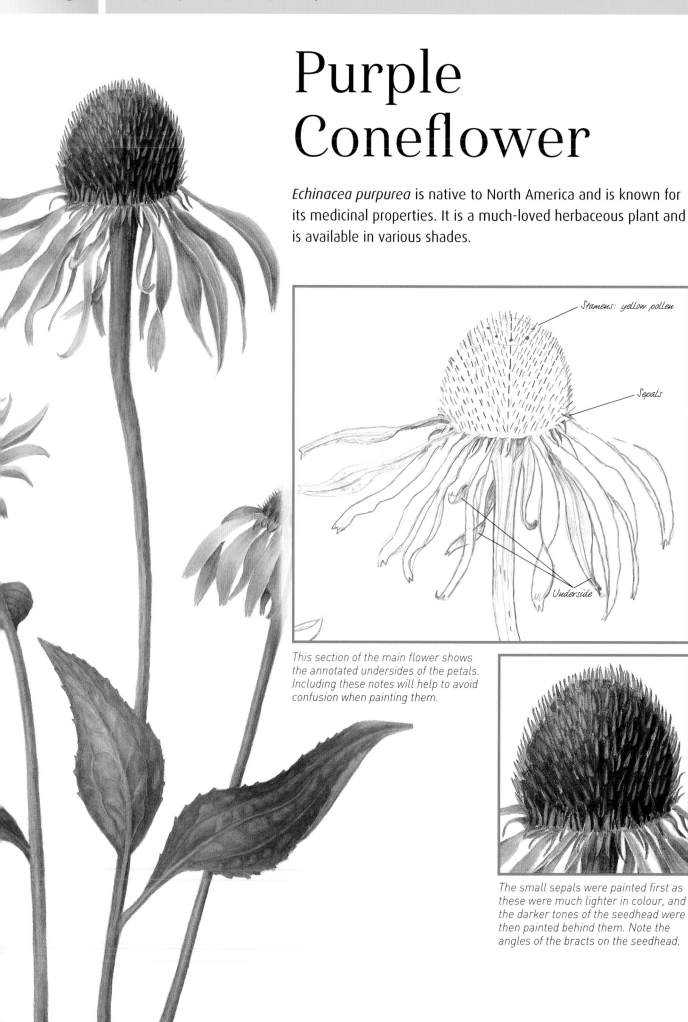

Stamens: yellow pollen

Sepals

Underside

This section of the main flower shows the annotated undersides of the petals. Including these notes will help to avoid confusion when painting them.

The small sepals were painted first as these were much lighter in colour, and the darker tones of the seedhead were then painted behind them. Note the angles of the bracts on the seedhead.

Worksheet

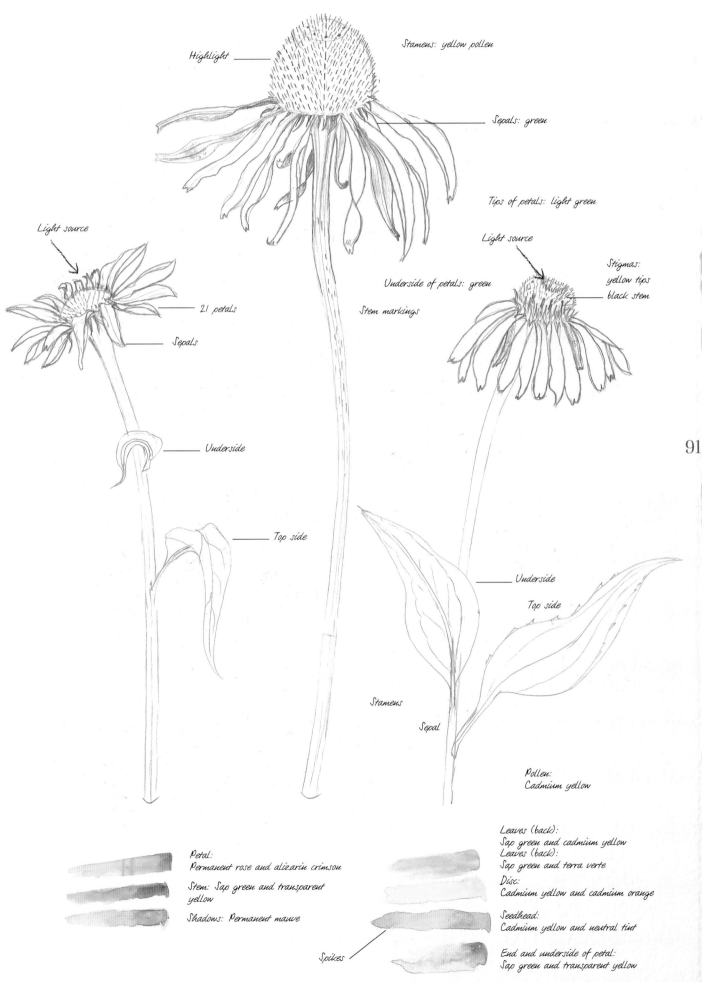

Highlight

Stamens: yellow pollen

Sepals: green

Light source

21 petals

Sepals

Underside

Top side

Tips of petals: light green

Light source

Stigmas:
yellow tips
black stem

Underside of petals: green

Stem markings

Underside

Top side

Stamens

Sepal

Pollen:
Cadmium yellow

Leaves (back):
Sap green and cadmium yellow
Leaves (back):
Sap green and terra verte
Disc:
Cadmium yellow and cadmium orange
Seedhead:
Cadmium yellow and neutral tint
End and underside of petal:
Sap green and transparent yellow

Petal:
Permanent rose and alizarin crimson
Stem: Sap green and transparent
yellow
Shadows: Permanent mauve

Spikes

Painting the coneflower

Transfer the drawing to hot-pressed watercolour paper once you have your sketch and paints ready.

First wash

1 Use a size 3 brush to glaze all of the petals, seedhead and stems with clean water and allow them to dry. Use a dilute mix of alizarin crimson and permanent rose to wash the top side of the petals, grading into the highlights and keeping the left-hand side of the flower petals a lighter tone. Repeat this on all of the flowerheads and leave them to dry.

2 Still using the size 3 brush, use a dilute mix of raw umber with a little neutral tint to paint in the seedheads, leaving a highlight on the top left of each.

3 Switch to a size 2 brush and a dilute mix of sap green and transparent yellow. Paint the underside of the petals and the small sepals, then swap to a size 3 to paint the stems with the same mix, grading from right to left.

4 Glaze the leaves with clean water and leave them to dry. Using a dilute mix of sap green and terra verte, paint in the tops of the leaves, grading into the highlights.

5 Use a dilute mix of sap green and cadmium yellow to wash the underside of the leaves, leaving the midribs free of paint.

6 With a size 1 brush and a dilute mix of cadmium yellow and cadmium orange, paint the centres of the two younger flowers (those to the left and right).

Tonal washes

1 Using the same size brushes and stronger mixes of the respective colours, repeat the above process on the different areas, grading the washes to achieve the necessary tone and build up the form. You will have to apply a number of washes in order to build up the required depth of colour.

2 Wash over the midrib with the leaf colour.

Crossovers

1 Use a size 1 brush and a dilute mix of alizarin crimson and permanent mauve to paint in the small areas where the petals overlap each other, in order to put the petals in their correct position.

2 Use the same size brush and a mix of neutral tint to paint in the small areas where the leaves overlap the stems, grading the paint into the green of the stems.

Harmonisation

With a size 2 brush and a dilute mix of sap green and transparent yellow, apply a small wash to the lower parts of the petals. Paint a small wash of a dilute mix of permanent rose and alizarin crimson over the upper parts of the flower's leaves.

Details

1 Use a stronger mix of cadmium orange with a size 1 brush to paint the bracts on the cone of the central (oldest) flower, starting from the centre and working from left to right. Repeat this until the correct tone has been achieved, then add a little neutral tint to the mix for the bracts in the shadow area. Repeat the process on the other flowerheads.

2 Use a stronger mix of neutral tint and a size 0 brush to paint in the stamens and stigmas, then add the pollen using cadmium yellow. Still using the size 0 brush, use a dilute mix of neutral tint and raw umber to paint the speckled markings on the flower stems.

3 With a size 1 brush and sap green, paint in the tips of the petals, grading the colour into the pink of the petals. Use a 2mm (⅛in) flat brush to gently lift out the veins on the leaves.

Discretionary washes

I used a size 3 brush with a dilute mix of transparent yellow and sap green to wash over the top side of the leaves and the flower stems.

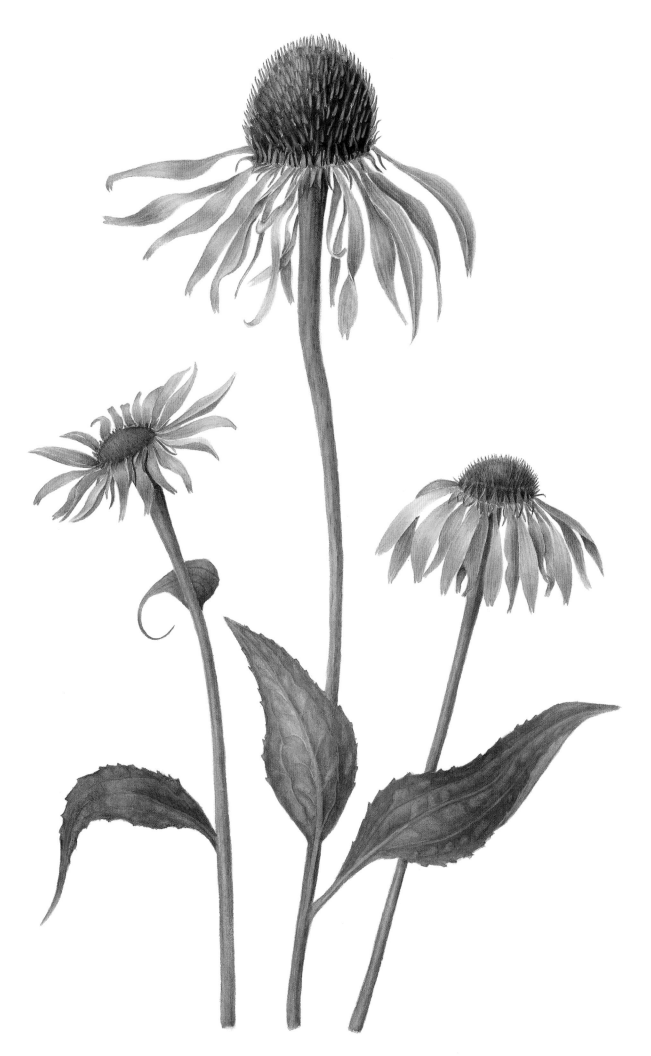

Fuchsia

Originally from Mexico, this flower was introduced to the gardens of England by Lee and Kennedy of Hammersmith in the 1780s. It is a delight to paint, as there are hundreds of colours. This variety is called 'Blacky', for obvious reasons.

94

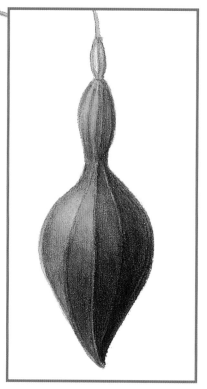

The bud was given several washes of the alizarin crimson and opera rose mix and allowed to dry. The raised sepal edges were then shadowed on the right-hand side to make them raised using the flower colour mix.

When painting in the stigmas and stamens, make sure that you leave a highlight to suggest their three-dimensionality. Although very small, they still have a distinct form.

Shadowing was added in the ridges to create form and shape. Note the highlight on the top left – ensure that the light is falling from only one light source to avoid a confusing image.

Worksheet

Margin

Midrib

Underside

Second flower stem

Underside

Tube

Convex

Convex

Concave

Concave

Fruit colour/seed pod:
Same as corolla plus neutral tint

Buds:
Alizarin crimson and opera rose

Fruit

Lower stem:
Raw umber and alizarin
crimson, same as stamens

Young stem upper:
Lower, older leaves:
Sap green and alizarin crimson

Young leaves:
Sap green and transparent yellow

Stamens:
Alizarin crimson and French ultramarine

Corolla:
French ultramarine, alizarin crimson
Permanent magenta and cadmium yellow

Petals and tube:
Alizarin crimson and opera rose

Ovaries:
Sap green and transparent yellow

Painting the fuchsia

With your sketch to hand and your colours prepared, transfer the drawing to hot-pressed watercolour paper.

First wash

1 Use a size 2 brush to glaze all of the petals and sepals with clear water and leave them to dry.

2 Use the same brush to apply the first dilute wash of French ultramarine, alizarin crimson and permanent magenta with a touch of cadmium yellow to the corolla, leaving the highlight unpainted but grading into it. Allow to dry.

3 Paint the sepals and tube with a dilute mix of alizarin crimson and opera rose, again leaving the highlights unpainted but grading into them.

4 Glaze all of the leaves with clean water and a size 3 brush, then leave them to dry.

5 Using a dilute mix of sap green and alizarin crimson, paint in the first wash on the four larger leaves, working from the midrib to the left, leaving the highlights; then grade the paint to the right-hand side of the leaf.

6 With a size 2 brush and a dilute mix of sap green and transparent yellow, paint the two young leaves, leaving the midrib unpainted. Using the same brush and the same mix, paint the green stalks grading from right to left, then glaze the stem with clean water and leave to dry.

7 Still using the size 2 brush, use a dilute mix of raw umber and alizarin crimson to paint the stem, grading it from right to left and add more alizarin crimson towards the upper part of the stem. Use the same mix of paint on the thin flower stems and the four flower buds, again grading into the highlights.

8 With the same mix as for the corolla, apply the first wash to the seed pod, grading each segment from right to left and leaving the highlights unpainted. Leave to dry.

Tonal washes

1 Using the size 2 round brush, start to build up the depth of colour on the corolla using a slightly stronger version of the same mix as before.

2 Carefully grade each petal to create form and tone, then use a slightly stronger sepal mix to paint the centres. When gradated out to the lighter areas, this gives a concave look.

3 Paint the vertical lines on the tubes and the flower buds, then build up the depth of colour on the leaves, grading from each vein to create surface modelling.

4 Darken the stem to the required tone and build up the form on the seed pod to create a three-dimensional look.

Crossovers

1 Using a size 2 brush and a mix of alizarin crimson and neutral tint, paint in the small areas where the tubes overlap the sepals and where the sepals overlap the tubes to create the impression of distance.

2 Shade where the leaves overlap the stems.

Harmonisation

1 Using a size 2 brush, paint a dilute wash of alizarin crimson on the lower part of the two lower leaves.

2 Next apply a small wash, of a dilute mix of transparent yellow and sap green, to the upper petals of the flower sepals and to the flower and bud stalks.

Details

1 Use a slightly stronger mix of alizarin crimson and a size 1 brush to paint in the leaf veins and the small serrations on the leaves.

2 Use the same mix to paint in the styles and stigmas, then add more neutral tint to the mix to darken the stigma and stamens.

3 With a size 1 brush and a mix of raw umber and alizarin crimson, paint in the stem on the seed pod and the small circle at the top of the stalk.

Discretionary washes

Using a size 3 brush and a dilute mix of transparent yellow and sap green, I washed over all of the leaves keeping accurately to the edges, then left the portrait to dry.

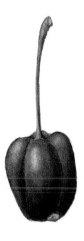

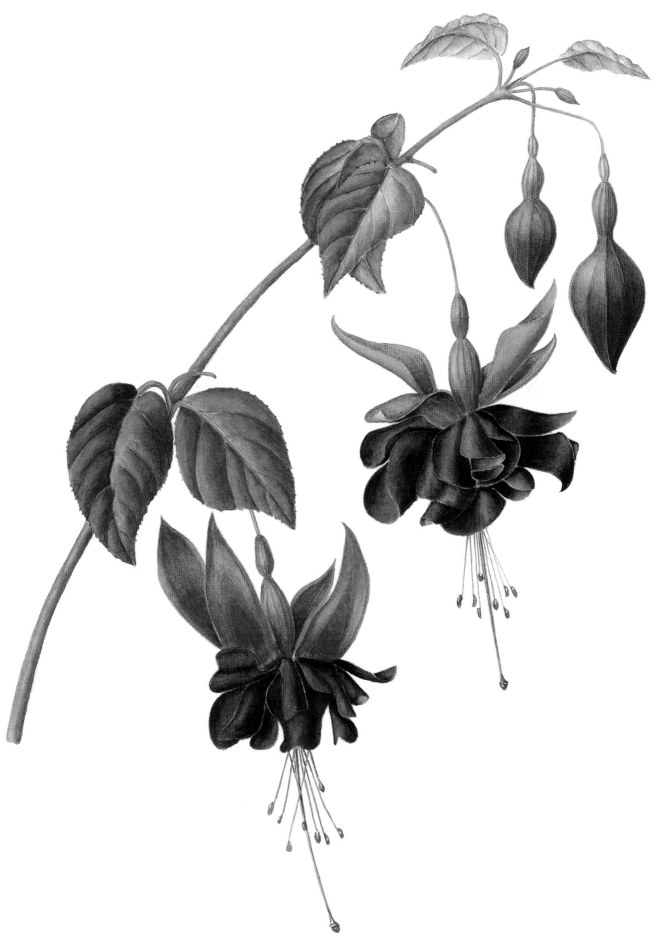

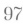

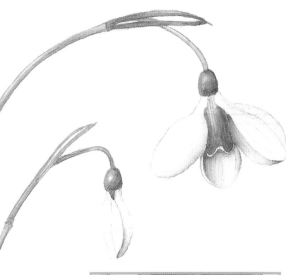

Snowdrops

There are three main genera of snowdrops: the Turkish *elwesii*, the Russian *plicatus* and the *nivalis*, which is the most widespread and best known. The main difference between the three is the shape of the leaves, and the variety can be identified from the different markings on the inner petals.

This finished painting contains the three main genera. From left to right, they are *plicatus*, *nivalis* and *elwesii*.

Snowdrop leaves on an individual plant do not vary much in hue, but different varieties have different hues. The plicatus *leaves (left) have more yellow in the mix than the other two, while the* elwesii *leaves (right) are much darker than the others and have comparatively more blue in the mix. Good observation is required to note the difference.*

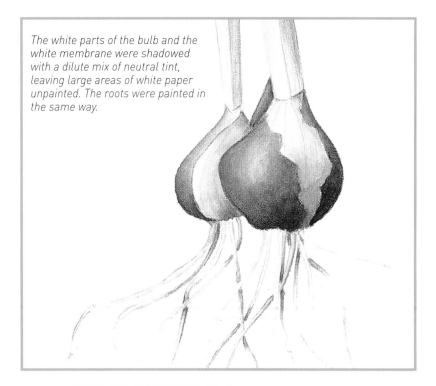

The white parts of the bulb and the white membrane were shadowed with a dilute mix of neutral tint, leaving large areas of white paper unpainted. The roots were painted in the same way.

Composition
Basic sketches were made of each of the varieties, and these were then rearranged for a more pleasing final composition.

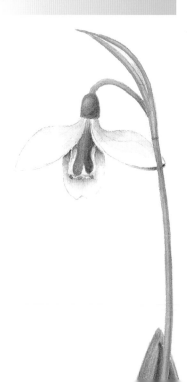

Worksheet

Light source

Two flower stems

(3)

(2)

Highlights

Highlights
(1)

Very light

Centre
white

Green

White

White
and grey

Highlight

Stem:
Round

Stem:
Yellow/green

Midrib

Stem: Oval

Light area
green

Stem: Dark
green

Highlight

Outer leaf

Green

Outer leaf

To green

Russian
variety

Shadow

White

Membrane

White to
green

Highlight

Light green

Leaves:
Add Winsor yellow
to nivalis mix

Bulb
skin
Shadow arch
and membrane
and flowers

White

Blue-green

Leaves
and
stems

Idea for
composition

Yellow-green

99

Raw umber and neutral tint

Neutral tint

Nivalis (1) Centre
Elwesii (2) Right (on painting)
Plicatus (3) Left

Same mix as below, plus
transparent yellow

Manganese blue, Winsor green
and yellow shade.

Sap green
Manganese blue
Alizarin crimson
Russian Leaves

Painting the snowdrops

Transfer the drawing to your hot-pressed watercolour paper, prepare your wells of colour and place your sketch nearby for reference.

First wash

1 Glaze all of the leaves using a size 2 brush and clean water, then leave them to dry. Use a dilute mix of manganese blue and Winsor green (yellow shade) to paint the first wash on to the leaves of the nivalis and elwesii, grading into the highlights and leaving the lower membrane and midrib unpainted.

2 Use the same size brush with a mix of sap green, manganese blue and a little alizarin crimson to paint the leaves on the plicatus variety, leaving the lower membrane unpainted. Glaze the stems and flowerheads with clean water and leave them to dry.

3 Using a mix of manganese blue, Winsor green (yellow shade) and transparent yellow, paint the stems, leaving the highlights clean.

4 With a size 2 brush and a dilute mix of raw umber and neutral tint, apply a wash to the outer skin of the bulb, grading into the highlights.

5 Use a dilute mix of neutral tint and vertical strokes of the brush to paint the lower membranes on all of the three lower leaves, leaving the highlights unpainted. Using a size 1 brush and a dilute mix of neutral tint, paint in the shadows on the flower petals, grading from dark to the white areas.

Tonal washes

1 Develop the nivalis leaves with the stronger manganese blue and Winsor green (yellow shade) wells. Leave the midribs unpainted.

2 Again leaving the midribs unpainted, add Winsor yellow to the mix to paint the elwesii and plicatus leaves.

3 Replicate the previous steps, using the stronger wells to deepen the tone but ensure that you leave the highlights. Repeat until you achieve the correct tone.

Crossovers

1 Using a size 1 brush and neutral tint, shadow the areas where the leaves cross to separate and distance them from each other.

2 Use the same colour to add shadows to the roots where the roots cross, being careful to grade it into the white highlight areas.

3 Add shadows to the flower petals in the same way but be careful not to over-shadow them: you do not want grey flowers.

4 Repeat the crossover steps until you achieve the correct depth of tone.

Harmonisation

There is no harmonisation needed on this illustration.

Details

1 Use a size 0 brush with a mix of sap green and transparent yellow to paint in the green area of the bud on the nivalis and also the ovaries on all of the flowers, leaving a highlight on each one.

2 With the same mix and brush, paint in the patterning on the inner petals. Next, use a dilute mix of neutral tint to paint the vertical lines on the membrane of the lower leaves and the curved lines on the bulbs.

3 Add further detail to the roots and the lines on the petals with the same mix.

Discretionary washes

I used a size 3 brush and a dilute mix of transparent yellow to apply a wash to the leaves on the *elwesii* and *plicatus* and a dilute mix of manganese blue to wash over the petals on the nivalis.

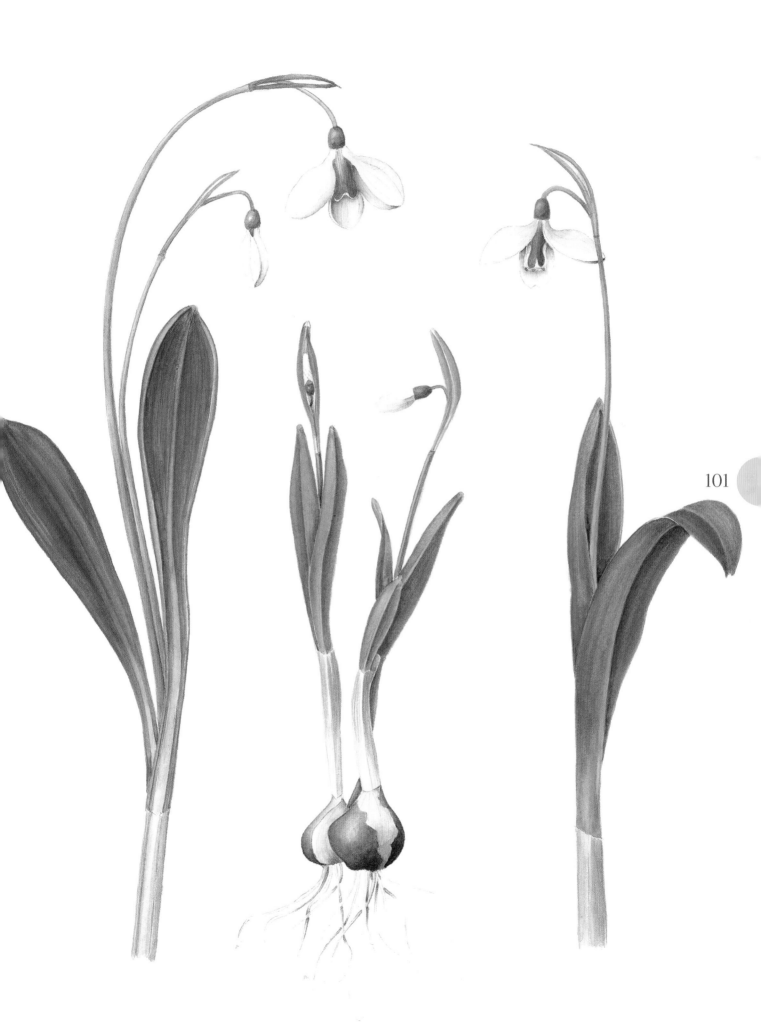

Magnolia

In spring, these flowers start with a furry brown sheath, then burst into a spectacular array of pink or white flowers. After the petals have fallen, you can see the stigmas and stamens standing proud. The leaves appear after the flowers have finished.

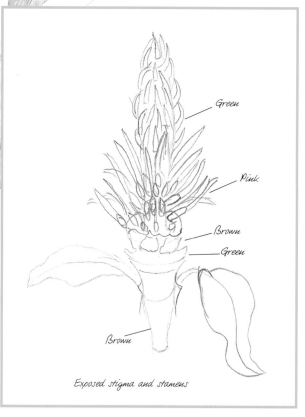

Green

Pink

Brown

Green

Brown

Exposed stigma and stamens

The initial pencil drawing was used to note the various colours of the stigmas, stamens and sepals. Complex areas like this benefit from additional notes before you start to paint.

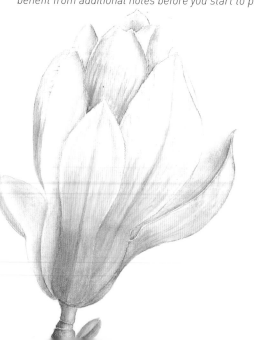

102

The bud casings of the flowers have a furry texture to them. You will have to work slightly wet-in-wet to achieve this, but note that it is a careful balance: if your paper is too wet the effect will be lost.

Worksheet

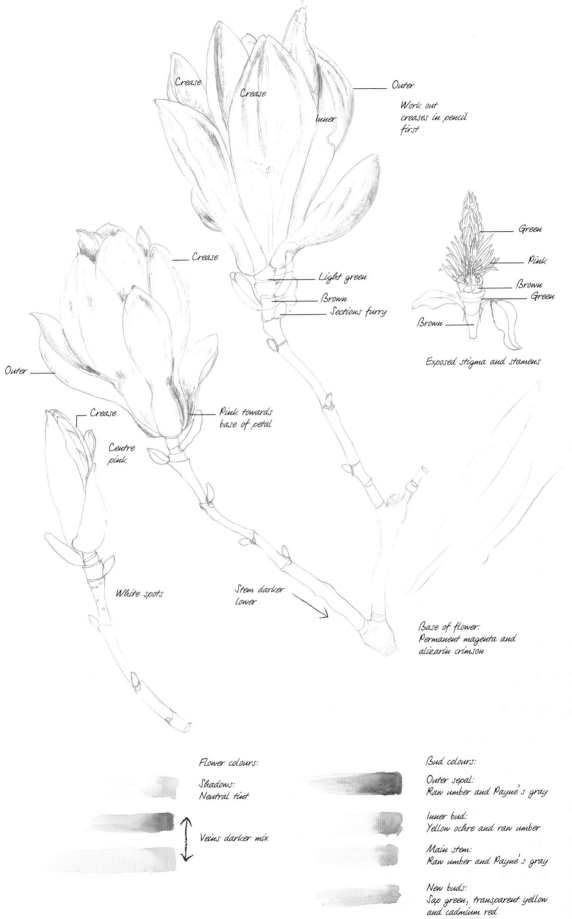

Crease

Crease

Inner

Outer

Work out
creases in pencil
first

Green

Pink

Brown
Green

Brown

Exposed stigma and stamens

Crease

Light green

Brown

Sections furry

Outer

Crease

Centre
pink

Pink towards
base of petal

White spots

Stem darker
Lower

Base of flower:
Permanent magenta and
alizarin crimson

103

Flower colours:

Shadows:
Neutral tint

Veins darker mix

Bud colours:

Outer sepal:
Raw umber and Payne's gray

Inner bud:
Yellow ochre and raw umber

Main stem:
Raw umber and Payne's gray

New buds:
Sap green, transparent yellow
and cadmium red

Daffodils

Narcissus is a perennially popular spring flower, with varieties ranging in colour from white to yellow to orange. Over 25,000 varieties have been identified since the 1870s. The variety shown here is 'Pipe Major'.

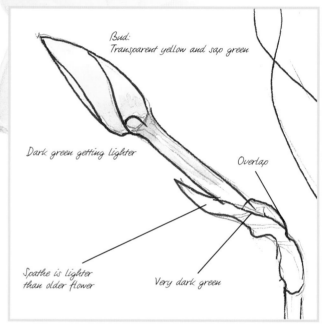

During the planning stage, along with your notes you might like to try some test washes on the sketch before the real painting begins. Such experiments are beneficial, and can act as a useful reference later on.

This detail show the spathe, a type of modified leaf which protects the bud before it flowers. Once the flower blossoms, the spathe starts to die, so a crinkled effect is required. Wavy lines leaving highlights will give this effect.

A slightly stronger mix of cadmium orange is used to darken the inside of the throat of the trumpet. This must be gradated towards the outer edge otherwise the depth will be lost.

Worksheet

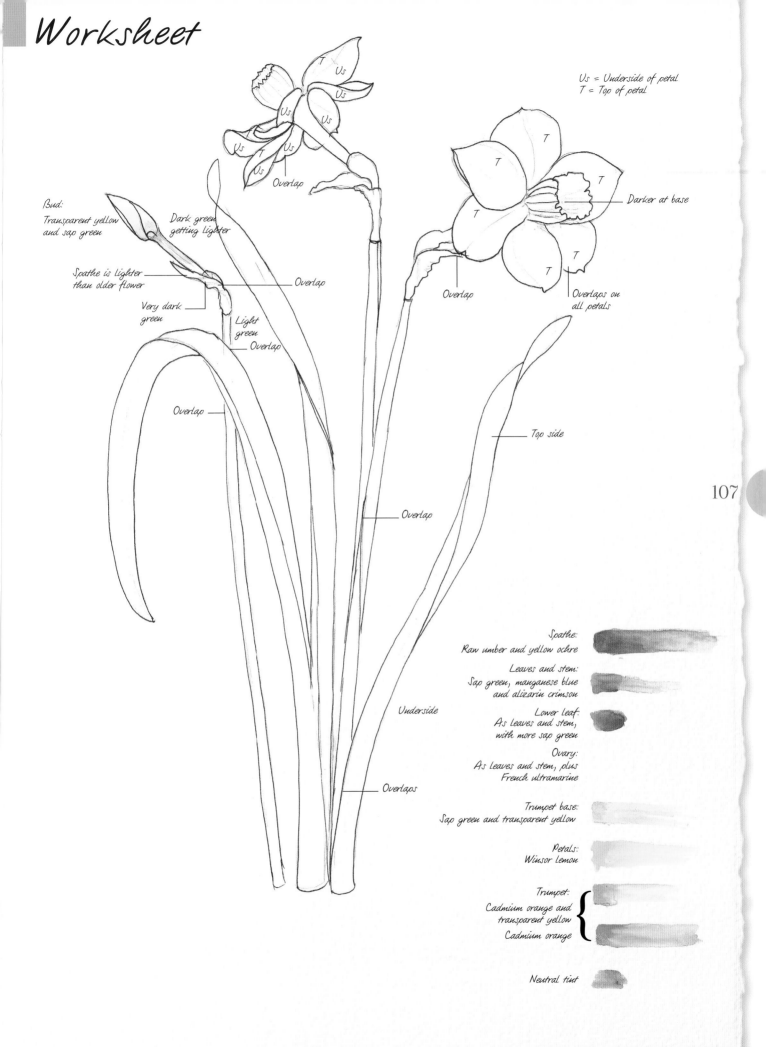

Us = Underside of petal
T = Top of petal

Bud:
Transparent yellow
and sap green

Dark green
getting lighter

Spathe is lighter
than older flower

Very dark
green

Light
green

Overlap

Overlap

Overlap

Overlap

Overlap

Overlap

Darker at base

Overlaps on
all petals

Overlap

Top side

Overlap

Underside

Overlaps

Spathe:
Raw umber and yellow ochre

Leaves and stem:
Sap green, manganese blue
and alizarin crimson

Lower leaf:
As leaves and stem,
with more sap green

Ovary:
As leaves and stem, plus
French ultramarine

Trumpet base:
Sap green and transparent yellow

Petals:
Winsor Lemon

Trumpet:
Cadmium orange and
transparent yellow

Cadmium orange

Neutral tint

Geranium

Geraniums have been popular with European growers since 1701 and have never really gone out of fashion. Doubtless some of their popularity stems from their great variety of vibrant colours: reds, whites and pinks are eye-catching and striking. This variety is *Pelargonium zonale* 'Ricard Orange'.

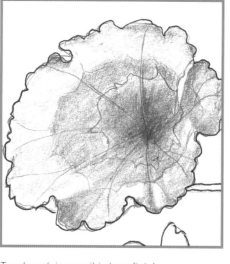

Tonal work in pencil is beneficial to accentuate the sometimes complex form of a component such as this geranium leaf.

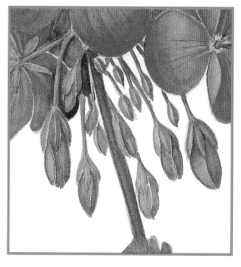

Although small, the new flower buds have a distinct shape. To suggest this, leave a highlight aiming towards the light source.

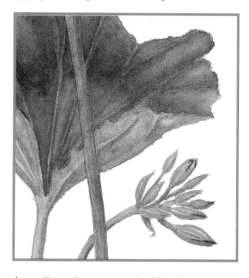

A small overlap was required for the main flower stem in front of the smaller one. The dark tones of the leaf form the shadow for the main stem.

Worksheet

White stigma

Small white lines in throat of flower

Gradated to
give form

Flowers:
Winsor red and transparent yellow

Sepals:
Sap green and cadmium
red

Darker vein

Veins:
Light green
Fading darker after light patterning

Some tonal work
to create form

Overlap

Dark patterning
fading to margin

Light green

Dark green

Add transparent
yellow to mix

Dark area
of stem

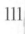

Underside of leaves:
Sap green and a little titanium white

Flower:
Winsor red

Old stem:
Sap green and alizarin crimson

Winsor red and transparent yellow

Stems:
Sap green, cadmium red and
transparent yellow

Shadows:
Neutral tint

Dark parts of leaf:
Sap green, Payne's gray and cadmium red

Light areas of leaf:
Sap green and cadmium red

Painting the geranium

With your sketch to hand and your colours prepared, transfer the drawing to hot-pressed watercolour paper.

First wash

1 Using a size 3 brush and clean water, glaze all of the petals individually and leave to dry. Using a dilute mix of Winsor red and a little transparent yellow, paint every alternate petal. Start each at the throat of the flower, grade the colour out towards the highlights on the bends of the petals and strengthen the colour towards the outer margin of the flowers.

2 Once dry, repeat this process on all of the remaining petals. Using the same brush, glaze all of the leaves and stems with clean water and leave the painting to dry.

3 Apply a dilute mix of sap green and cadmium red to the undulating leaf, grading into the highlights and leaving the veins unpainted.

4 Still using the size 3 brush and a dilute mix of sap green and alizarin crimson, paint the older lower part of the stem, grading from right to left and leaving the leaf nodes unpainted.

5 With a dilute mix of sap green, cadmium red and transparent yellow, paint the small stems of the flower buds and sepals, the young leaves and the main flower stem. Grade from right to left for each stem.

Tonal washes

1 Using a size 3 brush and a dilute mix of sap green, Payne's gray and a little cadmium red, paint the darker areas of the leaves and blend the paint into the lighter green, keeping the form as before.

2 Using a size 2 brush and a stronger mix of Winsor red, build up the form on the flower petals and buds.

3 Continue to build up the leaves with the mix in step 1 until the depth of colour has been reached. On the last two or three washes paint over the leaf veins to achieve a subtle colour.

Crossovers

Using a size 2 brush and a mix of neutral tint, darken the small areas where the leaves overlap the stems, the stems overlap the leaves and the bud stems cross each other, in order to put them in the correct position.

Harmonisation

1 Using a size 3 brush and a dilute mix of Winsor red and transparent yellow, apply a small wash to the leaf closest to the flowerhead.

2 Still using the size 3 brush, add a small wash of sap green and transparent yellow to the lower flower petals and buds.

Details

1 Using a size 0000 brush and a little white gouache, paint in the stigmas and stamens of the open flower.

2 Switching to a size 1 brush and a mix of sap green with a little white gouache, paint the undersides of the leaves, leaving the veins unpainted.

3 With a mix of sap green and transparent yellow, paint in the small leaves at the nodes, grading the paint to keep the form.

Discretionary washes

Using a size 5 brush and a dilute mix of transparent yellow and sap green, I washed over all of the leaves and stems. Using a size 1 brush and transparent yellow, I then washed over the individual petals on the left of the portrait.

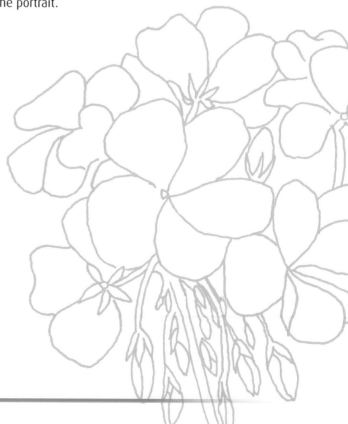

Bird of Paradise Flower

Originally from the Cape region of South Africa, the exotic-looking bird of paradise flower was named in honour of Queen Charlotte of Great Britain. Also called the crane flower, its botanical name is *Strelitzia reginae.*

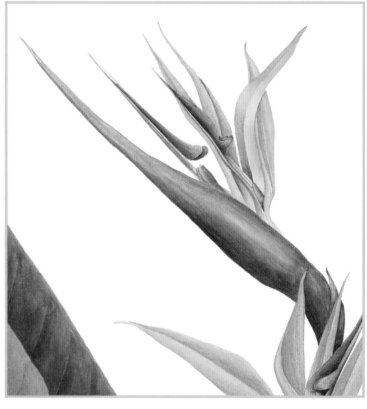

This sheath housed the main flower before becoming detached. Plant components such as this make for interesting details on your painting, and are worth just as much time and effort as the other parts of the plant. With the light source coming from the top left, the shadow is on the left-hand side inside the sheath and the right-hand side is catching all of the light. This gives the illusion that the inside is hollow.

When painting the 'beak' of the flower, care must be taken to grade each colour into the others to achieve a subtle change without hard edges. This is achieved by not using too much water in either the first wash or the tonal wash stages.

Worksheet

Base of petals:
Orange to white

Thin lip:
Alizarin crimson

Brown

Alizarin to sap green

Fading and more yellow

Light

Oval section

Shadow

Stem colours:
Transparent yellow

Sap green and
transparent yellow

Petal colours:
Cadmium orange

Alizarin crimson

Stigmas and stamens:
French ultramarine
and alizarin crimson

Outer leaf:
Manganese blue,
cadmium yellow and
French ultramarine

Inner leaf:
Cadmium yellow and
French ultramarine

Leaf midrib:
Cadmium yellow,
transparent yellow and
French ultramarine

Sheath:
Raw umber and
yellow ochre

Painting the bird of paradise flower

Prepare your wells of colours and place your sketch close by before transferring the drawing to hot-pressed watercolour paper.

First wash

1 Using a size 5 brush, glaze all of the flower petals, stigmas and stamens with clean water. Once dry, use a dilute mix of cadmium orange and transparent yellow to apply the first wash to the petals, grading from the shadow areas into the highlights. Repeat the process on the second flower.

2 Switch to a size 2 brush and use a dilute mix of French ultramarine and alizarin crimson to apply the first wash to the stigmas and stamens, again grading the paint to suggest the form.

3 With a size 5 brush, glaze the sheath and stems with clean water and leave them to dry, then use a dilute mix of sap green to paint the underside of the sheath grading into the centre.

4 Using the same size brush and a dilute mix of sap green and a little alizarin crimson, paint the two stems grading them from right to left and keeping the centre of each a lighter tone.

5 Use a size 6 brush to glaze the large leaf and midrib with clean water. Once dry, use a dilute mix of manganese blue, cadmium yellow and French ultramarine to paint the back of the leaf (outer – see page 111), grading from the midrib to the margin. Leave to dry.

6 Using the same brush and a dilute mix of cadmium yellow and French ultramarine, wash the inside of the leaf, grading the paint from left to right.

7 Paint in the midrib using a dilute mix of cadmium yellow, French ultramarine and a little transparent yellow, leaving the centre section a lighter tone.

8 Glaze the brown sheath using a size 2 brush and clean water. Once dry, use a dilute mix of raw umber and yellow ochre to paint the sheath, using vertical strokes and grading into the highlights.

Tonal washes

1 Using the same size brushes and stronger mixes of the colours, repeat the process in the first wash steps, making sure to leave the highlights in lighter tones.

2 When painting the sheath, use horizontal strokes to form the lines. Let each wash dry before applying another. Lift out the veins on the leaf with a 2mm (⅛in) flat brush.

Crossovers

1 With a size 1 brush, apply a dilute mix of neutral tint to the areas that overlap each other, paying particular attention to the petals over the sheath and the sheath over the stems.

2 Allowing each layer to dry before applying the next, repeat the application of the washes until the depth of colour gives the correct impression of distance between the components.

3 Using the same mix and a size 2 brush, add the shadows behind the veins to add emphasis to them.

Harmonisation

1 Use a size 3 brush and a dilute mix of sap green to paint a small wash underneath the sheath on the top flower, grading into the alizarin crimson. Apply the same wash to the underside of the lower sheath.

2 With a dilute mix of cadmium orange, apply a small wash to the top right-hand side of the inner leaf.

Details

1 Using a mix of cadmium orange and transparent yellow and a size 1 brush, sharpen up the points on the flower petals.

2 With the same brush, use French ultramarine to paint the sharp points of the stigmas.

Discretionary washes

I used a size 6 brush and a dilute mix of manganese blue to wash the underside of the leaf, then added sap green to the mix to wash the inside of the leaf. The two stems were washed over with a dilute mix of transparent yellow using the size 6 brush.

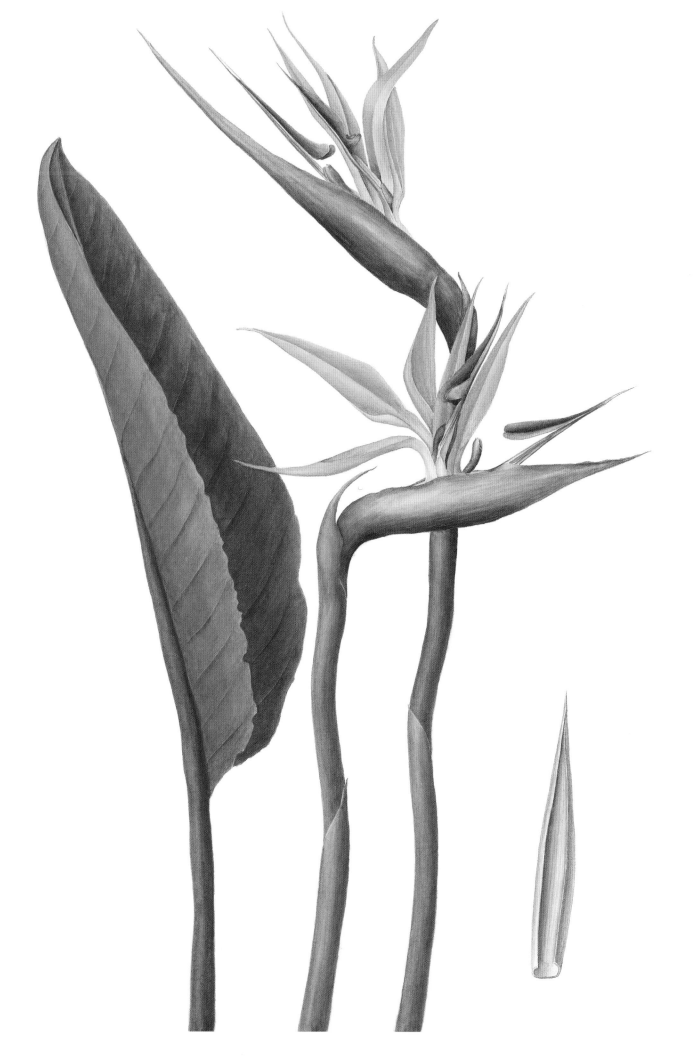

Pansy

Still a cottage garden favourite, *Viola tricolor* is the wild forerunner of modern garden pansies. It is known as heartsease in its native England, and as johnny jump-up in the USA. Since the early nineteenth century, many hybrids have been cultivated, with great variety in colour and size.

118

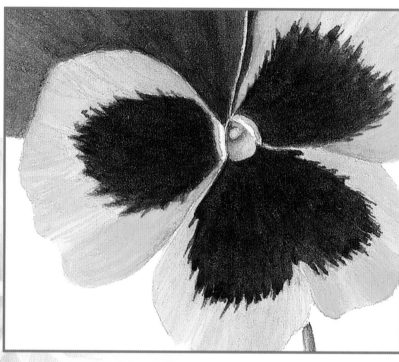

The dark areas of the three lower petals are not mixed as one colour. Instead, separate washes are applied sequentially on to the yellow base colour to give the rich velvet effect.

Each separate seed inside each pod should be painted individually. Leave a highlight on each seed then add a shadow to the background to give more form to the seeds.

Worksheet

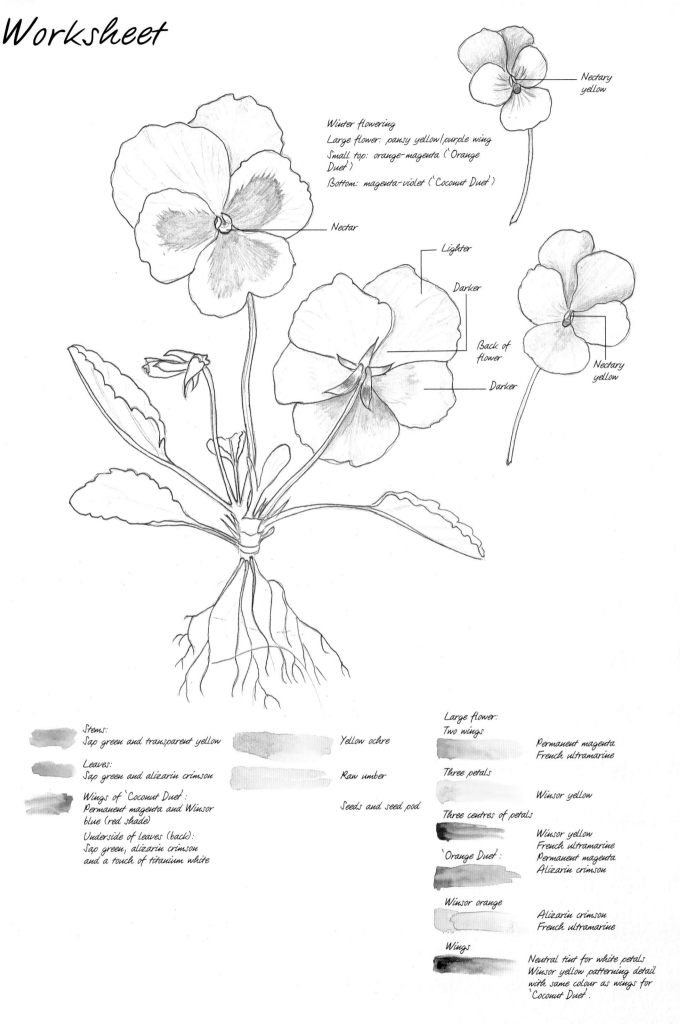

Nectary
yellow

Winter flowering
Large flower: pansy yellow/purple wing
Small top: orange-magenta (`Orange Duet`)
Bottom: magenta-violet (`Coconut Duet`)

Nectar

Lighter

Darker

Back of flower

Darker

Nectary yellow

Stems:
Sap green and transparent yellow

Leaves:
Sap green and alizarin crimson

Wings of `Coconut Duet`:
Permanent magenta and Winsor blue (red shade)

Underside of Leaves (back):
Sap green, alizarin crimson and a touch of titanium white

Yellow ochre

Raw umber

Seeds and seed pod

Large flower:
Two wings

Permanent magenta
French ultramarine

Three petals

Winsor yellow

Three centres of petals

Winsor yellow
French ultramarine
Permanent magenta
Alizarin crimson

`Orange Duet`:

Winsor orange

Alizarin crimson
French ultramarine

Wings

Neutral tint for white petals
Winsor yellow patterning detail with same colour as wings for `Coconut Duet`.

Painting the pansy

With your sketch to hand and your colours prepared, transfer the drawing to hot-pressed watercolour paper.

First wash

1 Using a size 3 brush, glaze all of the flower petals and allow them to dry. With a dilute mix of permanent magenta and French ultramarine, start to paint the topmost two petals of the picture, starting at the darker base and grading out to leave the highlights much lighter.

2 Paint in the small petals of the opening flower with the same mix and brush, then add a little alizarin crimson and apply the dilute mix to the two back petals, grading from the centre upwards into the lighter areas.

3 Once dry, use the size 3 brush with a dilute mix of Winsor yellow to start to paint the three other petals on the forward-facing flower. Again, start at the base. Ensure the stamens and nectary areas are left unpainted and grade the mix out towards the larger of the flower petals, leaving the highlights unpainted but grading into them.

4 Paint the back of the petals on the lower larger flower in the same way, leaving the highlights as before.

5 Using a size 2 brush and a dilute mix of alizarin crimson and French ultramarine, apply the first wash to the top two petals of the smaller 'Orange Duet' flower (top right), leaving the highlights as before.

6 With the same brush and a dilute mix of permanent magenta and Winsor blue (red shade), paint the top two petals of the 'Coconut Duet' flower (bottom right) using the same procedure as before.

7 Once both are dry, use the same size 2 brush and a dilute mix of Winsor orange to paint the three lower petals of the 'Orange Duet' making sure to leave the nectarines, stigma and stamens unpainted. Still using the same brush, but with a dilute mix of neutral tint, shadow the three lower petals of the 'Coconut Duet', leaving the white areas unpainted.

8 With the size 3 brush and clear water, glaze all of the stems and leaves. Once dry, use a dilute mix of sap green and transparent yellow to paint in the stems. These are square in section, so make sure that the right-hand sides are darker and not gradated.

9 Use the same dilute mix of sap green and transparent yellow to paint the sepals on the opening bud, the larger right-hand flower and the younger leaves.

10 With a mix of sap green and alizarin crimson, apply the first wash to the tops of the leaves and allow them to dry.

11 Add a little white gouache to the mix, and paint the underside (i.e. the back) of the leaves, leaving the veins unpainted.

12 Using a dilute mix of permanent magenta, alizarin crimson, French ultramarine and a little Winsor yellow, apply the first wash to the darker centre areas of the large main flower, starting from the centre and painting the pattern carefully as shown. Use a slightly dilute mix on the back of the other flower, creating the pattern as you work.

Tonal washes

Referring to the first wash steps for the appropriate brush size and mixes, repeat the steps above, building up the tone and form by using slightly stronger mixes.

Crossovers

1 Using a slightly stronger mix of neutral tint and a size 1 brush, paint in the small areas where the petals and sepals overlap.

2 Paint in the crossovers on the stems and leaves in the same way.

3 Repeat the steps until the individual components look correctly distanced and separate from each other.

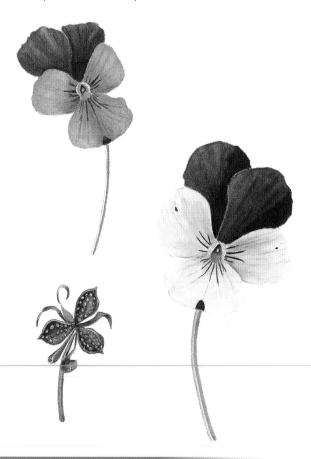

Harmonisation

Use a size 2 brush and a dilute mix of sap green and transparent yellow to apply a small wash to the base of the petals on both of the large flowerheads.

Details

1 With a size 1 brush and a slightly stronger mix of permanent magenta and Winsor blue (red shade), add patterning to the 'Coconut Duet' petals.

2 Using a stronger mix of alizarin crimson, French ultramarine and neutral tint, add the patterning to the 'Orange Duet'.

3 Change to the size 0 brush and use a dilute mix of yellow ochre to paint the seeds in the seed pod, leaving a highlight on each seed.

4 Once the seeds have dried, paint the pods and sepals using raw umber for the shadows. Add a little neutral tint to darken the tone until it is correct.

5 Still using the size 0 brush, paint the fine lines on all of the darker petals with a stronger mix of permanent magenta and alizarin crimson, and painting from the centre outwards.

6 Using a size 1 brush and a dilute mix of neutral tint, start to paint in the root system, grading into the highlight areas and darkening the areas in the background, keeping the front roots much lighter.

7 Once the roots have dried, follow the crossover instructions above to put the roots in position.

8 With the same brush and a dilute mix of raw umber, paint in the basal plate where the roots emerge.

9 With a size 0 brush and a mix of Winsor yellow, paint the stamens and stigmas on all of the flowers, adding a little sap green to the mix where necessary.

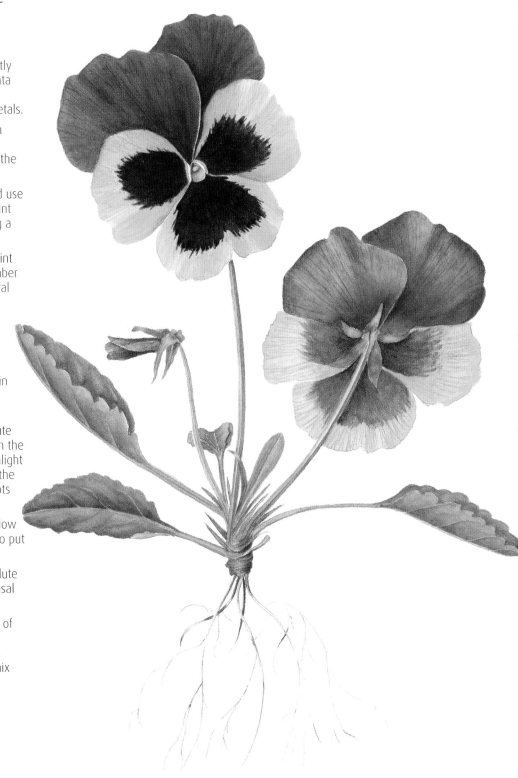

Yucca

Yucca flaccida is an evergreen short-stemmed shrub that produces tufts of narrow dark green leaves alongside long attractive panicles of bell-shaped creamy-white flowers.

When closed, the buds are light green with much lighter veins. These must be left unpainted, which is best achieved by working your brush in long strokes alongside the veins that run the length of the leaf.

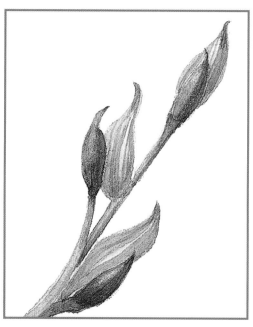

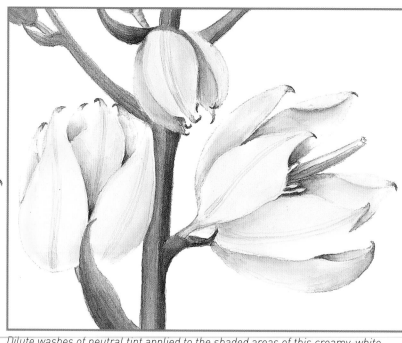

Dilute washes of neutral tint applied to the shaded areas of this creamy-white flower help to give the petals form and structure. This is best done at an early stage before the light greens are applied, as otherwise the petals can appear flat and uninteresting.

Worksheet

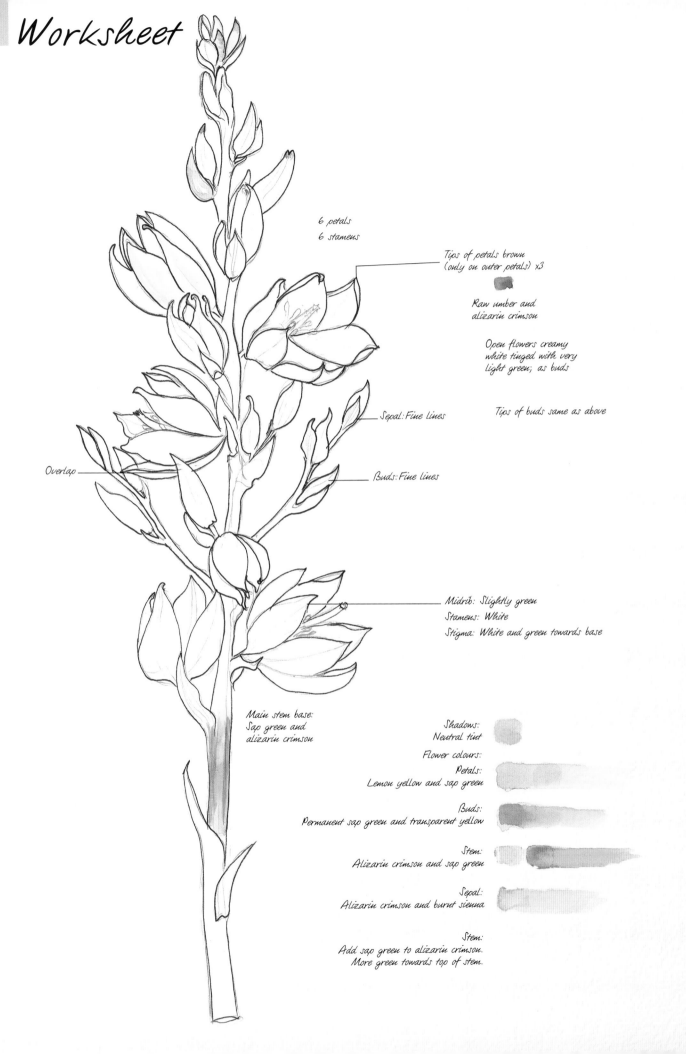

6 petals
6 stamens

Tips of petals brown
(only on outer petals) x3

Raw umber and
alizarin crimson

Open flowers creamy
white tinged with very
light green; as buds

Tips of buds same as above

Sepal: Fine lines

Buds: Fine lines

Overlap

Midrib: Slightly green
Stamens: White
Stigma: White and green towards base

Main stem base:
Sap green and
alizarin crimson

Shadows:
Neutral tint

Flower colours:
Petals:
Lemon yellow and sap green

Buds:
Permanent sap green and transparent yellow

Stem:
Alizarin crimson and sap green

Sepal:
Alizarin crimson and burnt sienna

Stem:
Add sap green to alizarin crimson.
More green towards top of stem.

Painting the yucca

With your sketch to hand and your colours prepared, transfer the drawing to hot-pressed watercolour paper.

First wash

1 With a size 2 brush and clean water, glaze all of the petals and stem and allow them to dry. As the flower is predominantly white, use a dilute mix of neutral tint to paint the flowerheads and each of the petals and buds by applying the mix to the shadow areas to create form and depth.

2 Use the same brush with a dilute mix of sap green and transparent yellow to paint in the buds, grading each from right to left and leaving the highlights unpainted.

3 With a dilute mix of alizarin crimson and burnt sienna, paint the sepals in the same way as the buds.

4 Use a dilute mix of alizarin crimson and sap green to paint the stem. As the stem is almost square in cross-section, with strong angles, paint it to leave a line showing the shape of the section, adding more sap green towards the top of the stem.

Tonal washes

1 Use a size 2 brush to build up the shadow areas of the flowerheads with neutral tint. Once dry, use a dilute mix of lemon yellow and sap green to paint from the centre midrib of the outer petals and shadow areas. Be careful not to use too much of this mix or the white flower will look too green.

2 With a size 2 brush and the alizarin crimson and sap green mix, darken the stem on the right-hand side, keeping the square section.

3 Use a thicker mix of transparent yellow and sap green to build up the buds.

4 Build up the sepals using a thicker mix of alizarin crimson and burnt sienna.

Crossovers

Use a size 1 brush and a dilute mix of neutral tint to paint in the small areas where the petals, sepals and buds overlap each other, ensuring that you darken the areas in the distance a little more.

Harmonisation

1 Use a size 2 brush with a dilute mix of Winsor yellow and sap green to wash the sepals and buds closest to each other. This creates the effect of light reflecting a little of the colour from the sepals to the buds and vice versa.

2 With a dilute mix of alizarin crimson and burnt sienna, wash the petals closest to the buds and sepals to harmonise the colours.

Details

1 With a size 1 brush and a slightly thicker mix of alizarin crimson and raw umber, paint the tips of the outer petals and buds.

2 Use a mix of sap green and transparent yellow to paint in the stigmas, grading from dark to light, then use the same mix to paint the lines on the buds and stem.

3 Paint the lines of the sepals with a mix of alizarin crimson.

4 Switch to a size 00 brush and use white gouache to paint in the styles and stamens.

Discretionary washes

I used a size 2 brush and a dilute mix of transparent yellow to wash over the stems and green buds.

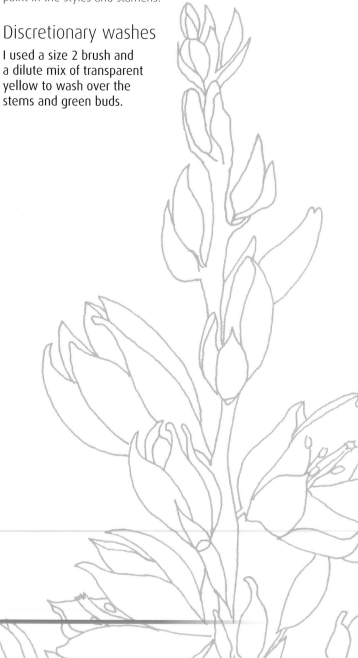

Finishing your work

When you think you have finished your work, leave it for a day or two, then scrutinise your painting to ensure your edges are neat and crisp. If necessary, remove any pencil marks with an eraser, and clean any other untidiness

I find that another artist's critique of the work is always useful before you declare the painting finished.

Tip

If you have had the misfortune to make erroneous marks with your paint, you can use a sharp scalpel to gently scrape them away from the surface. Once removed, smooth the paper using the back of a spoon.

Naming your work

The naming of plants follows an international system, to ensure the plant has a name recognisable in any part of the world in addition to its regional, common name.

Plant names have two parts, which is why the system is called binomial nomenclature. The first part of the name is the genus, and this is always capitalised. This is followed by the species, which is not capitalised. Both of these parts are italicised.

Some plants are grown for specific purposes, and while they remain the same species as one another, are distinct in appearance. These include different garden varieties of flowers, where the colour, shape or size may vary; and are known as cultivars. Cultivars are distinguished by the addition of a third name, which has an initial capital letter, is not italicised, and is enclosed by single quotation marks.

An example of naming:

Camelia japonica 'Jupiter'

Genus Species Cultivar/ variety

Mounting and framing your work

The mount you use needs to be of good quality. I would recommend archival quality mounts, which are acid-free and will not discolour with age. Off-white tones usually set off botanical paintings best, and you might like to experiment with double or triple mounts. Make sure you (or your framer) use acid-free tape on your work. I also recommend ultraviolet glass to help protect your work from fading.

Like the mount, the frame you use for your work is a personal choice, but I find simple, plain mounts best for botanical work, whether they be dark wood or natural oak or ash.

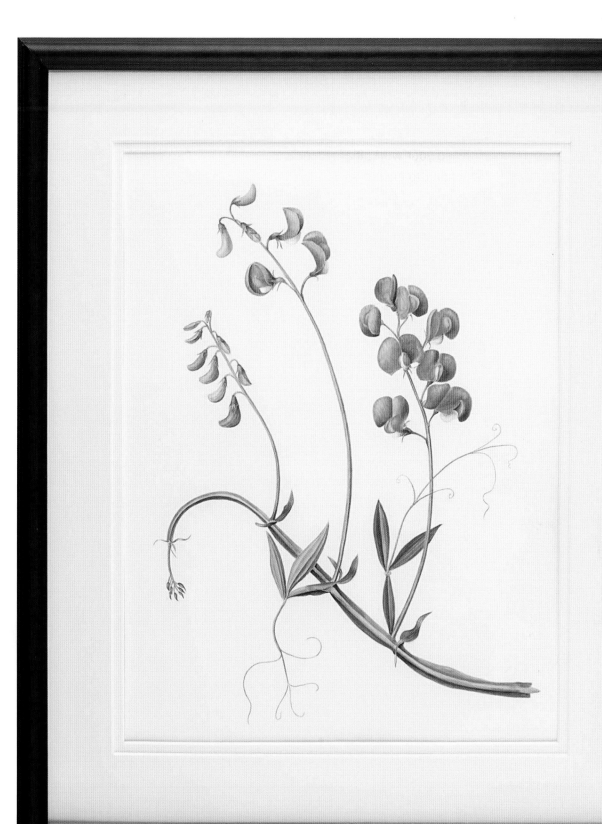

127

Index